KinoSputnik

THE COMMISSAR

KinoSputnik

THE COMMISSAR

Aleksandr Askoldov

Marat Grinberg

intellect Bristol, UK / Chicago, USA

First published in the UK in 2016 by
Intellect, The Mill, Parnall Road, Fishponds, Bristol, BS16 3JG, UK

First published in the USA in 2016 by
Intellect, The University of Chicago Press, 1427 E. 60th Street,
Chicago, IL 60637, USA

A catalogue record for this book is available from the British Library.

Copy-editor: Michael Eckhardt
Cover designer: Emily Dann
Production manager: Matthew Floyd
Typesetting: Contentra Technologies

ISBN: 978-1-78320-706-0
ePDF: 978-1-78320-707-7
ePUB: 978-1-78320-708-4

To my grandfather Mikhail Goldis with gratitude and love

CONTENTS

Note on transliteration

The Library of Congress system has been used throughout, with the following exceptions: when a Russian name has an accepted English spelling (e.g. Tchaikovsky instead of Chaikovskii; Chaliapin instead of Shaliapin), or when Russian names are of Germanic origin (e.g. Eisenstein instead of Eizenshtein; Schnittke instead of Shnitke).

Acknowledgements

I am grateful to Richard Taylor, Birgit Beumers and everyone at Intellect for taking on this project and making it a reality. I owe a debt of gratitude to Aleksandr Askol'dov, with whom I conducted a series of phone and Skype interviews in spring 2015. I am enormously thankful to Radislav Lapushin and Stuart Liebman for reading the manuscript in its entirety and offering their important suggestions. I am also thankful to Anna Kupinska and David Roizen for providing some of the archival materials and photographs. I am equally thankful to the staff at the Russian State Archive of Literature and Art for providing a copy of the film's script. I am fortunate to have been able to discuss *The Commissar* individually and at various conferences with Nancy Condee, Yuri Tsivian, Olga Gershenson, Harsha Ram, Luba Golburt, Harriet Murav, Elizabeth Duquette, and Katja Garloff. I am thankful to Hillary Larson for help with translating from French, and to Gennady Estraikh for help with understanding a Yiddish phrase in the film. Finally, writing this book was both an intellectual and personal journey for me. I was born in Kamenets-Podol'skii, ten years after *The Commissar* was shot there, and grew up with anecdotes about the production from my grandparents and mother, who then lived in the city: from spotting the actors and the crew around town, to the travails of a local Jewish woman who was injured by a horse during the shoot. I am grateful to my grandfather, mother and sister for their encouragement and support, and to my wife and son for their love, care and patience.

KinoSputniks general editors' preface

This series intends to examine closely some key films to have emerged from the history of Russian and Soviet cinema. Continuing from *KinoFiles* (2000–2010), the *KinoSputniks* are intended for film enthusiasts and students alike, combining scholarship with a style of writing that is accessible to a broad readership. Each *KinoSputnik* is written by a specialist in the field of Russian and/or film studies, and examines the production, context and reception of the film, whilst defining the film's place in its national context and in the history of world cinema.

Birgit Beumers & Richard Taylor
Wales, June 2016

List of illustrations

Production credits

Production Company:	Gor'kii Studio, Mosfil'm, 1966–67
Release Date:	11 July 1987
Director:	Aleksandr Askol'dov
Screenplay:	Aleksandr Askol'dov
Cinematographer:	Valerii Ginzburg
Production Design:	Sergei Serebrenikov
Composer:	Alfred Schnittke
Editor:	Natal'ia Loginova, Svetlana Liashinskaia and Nina Vasil'eva
Running Time:	110 minutes

CAST

Commissar Klavdiia Vavilova	Nonna Mordiukova
Efim Magazanik	Rolan Bykov
Maria Magazanik	Raisa Nedashkovskaia
Regiment's Commander Kozyrev	Vasilii Shukshin
Vavilova's lover	Otar Koberidze
Regiment's Officer	Leonid Reutov
Emelin	Viktor Shakhov
Grandmother (Efim's mother)	Liudmila Volynskaia
Roza Magazanik	Liuba Kats
Magazanik's Sons	Pavlik Levin, Igor' Fishman, Dima Kleiman
Street Musician	Vutsia Mitsman
Young Soldier	Vladimir Donilin
Catholic Priest	V. Grigor'ev
Rabbi	Valerii Ginzburg

Plot summary

The Commissar takes place during the Russian Civil War, in 1920 or 1921. A Red Army regiment enters a Jewish town in Ukraine, gloomy and half-ruined, with eerily empty cobblestone streets and decrepit mediaeval towers. The regiment is led by Commissar Klavdiia Vavilova, an imposing and coarse woman. Emelin, one of the soldiers, is arrested for desertion. Vavilova presides over his execution by firing squad in the town square. Her devotion to the Bolshevik cause is ruthless and fanatical.

The irony is that this crude 'manly' woman is pregnant. She confides her predicament to the regiment's commander who, baffled by the situation, reluctantly decides to have her stationed with a local Jewish family, in whose quarters she could give birth. The family are the Magazaniks, consisting of the father Efim, a poor tinker, his wife Maria, his elderly mother, and five small children: three boys, an older daughter and a baby. Efim is outraged by the 'addition' to his household. Non-ideological and living in the moment, he is the very antithesis of Vavilova. She treats the Jewish household as a foreign and frightening place.

Maria, an experienced and decisive woman, reaches out to Vavilova. Her suspicions that the commissar is carrying a child are confirmed. Maria 'educates' Vavilova in the ways of motherhood, domesticity and femininity, while Efim gradually warms to her as well. Vavilova in turn begins to feel much more comfortable in the new surroundings.

Assisted by Maria and the grandmother, Vavilova gives birth and experiences apocalyptic visions. She has a son. Proud of her child, she takes him on a walk through the town, where she visits the Orthodox cathedral, the Catholic church and the ruined synagogue. On the way back home, Vavilova is hounded by her regiment's soldiers. Once a brutal commissar, she turns into a defenceless woman.

The next day Vavilova is visited by the regiment's commander and an officer, who inform her that they will retreat from the town due to the advances of the Whites. Vavilova, who cannot travel with the baby, has no choice but to stay behind. Efim bravely tells her that she will remain with them, even if harbouring the commissar would jeopardize their very lives.

As the Reds withdraw and the town prepares for a new invasion, the Magazaniks and Vavilova are hiding in the house's cellar with the child. Efim is furious at his sons, who earlier engaged in a brutal game with their older sister. Pretending to be the perpetrators of a pogrom, they assaulted the girl and symbolically raped her. In the cellar, Vavilova and Efim engage in a debate about the nature of the Revolution and Jewish suffering. While he advocates the 'Internationale of kindness', she passionately argues for the necessity of Revolutionary violence. To comfort the children, who are frightened by the explosions outside, Efim engages them in a ritualistic dance. As Vavilova observes the Magazaniks, she experiences a Holocaust vision: the local Jews, with the Star of David on their clothes – among

them Efim with the family – march into a large, open stone structure with smoke billowing from its chimney, at the top of which sit inmates in striped uniforms.

The vision is interrupted and Vavilova rushes away from the cellar. She returns to the house and breastfeeds her son for the last time. The Red cadets pass by and she runs after them. Once in the house, Efim and Maria discover that Vavilova is no longer there; she has left the child behind in their custody and rejoined the troops.

Chapter 1
Introduction: Production history

Menashe: Ah, I see who the influences on you were. Eisenstein, Leonardo. In other words, your vision is very high...
Askol'dov: Marx and Lenin also.

(Menashe 2010: 302)

The City was awash with alarm, unease, and uncertainty.

(Bulgakov 2008: 10)

MAPPING *THE COMMISSAR*: ERAS, VOICES, POETICS

Aleksandr Askol'dov's film *Komissar/The Commissar* (1967) is a multi-layered and complex cinematic canvas. A landmark of post-war Soviet and twentieth-century European cinema, and one of the most (in)famous examples of the evils of censorship, it is a film of supreme intellectual, symbolic and emotional depth, cinematic innovation and political daring, with an especially rich network of literary sources. Produced at the end of the liberalizing Thaw period on the eve of the 50th anniversary of the Bolshevik Revolution, only to be completely banned for twenty years, *The Commissar* both engages with its era and transcends it. To appreciate the film today is to view it as a meeting place of diverse intersections – literary, cultural, political, visual and musical – whose contradictions nevertheless result in an incredibly unified compositional and mythological work. This first book about the film maps out, investigates and decodes these intersections.

Because of its unfortunate yet nonetheless fascinating history, *The Commissar* belongs to two eras: firstly, the 1960s; and then the beginning of perestroika of the late 1980s, when it was finally released. Debates about the film and its reception during both of these crucial periods that the book will examine offer an invaluably rich insight into the intellectual and political Soviet mindset, fluctuating between the dogmatic, the more liberal and the covert (often expressed in coded language). The story of the banning of *The Commissar* is well documented. Uncovered and presented in the initial years of perestroika, it was justifiably moralistic, aiming to restore justice to the persecuted film and its creator, and denounce the machinery of the Soviet inquisition. What is remarkable, however, is how much the film's overseers and judges – among them some of the most prominent members of the Soviet film industry – got right about *The Commissar*. As discerning oppressors rather than mumbling idiots or ideological automatons, they banned it to a large extent precisely because they got it right. The film frightened them. Thus, it behoves the viewer and the critic to listen to their voices, keeping in mind that listening here does not at all equal excusing.

Another voice that must be listened to, of course, is that of Aleksandr Askol'dov. While the film stands on its own as a remarkable artistic product, open to cycles of renewable interpretation yet still keeping in mind the collaborative nature of cinema, it is impossible to separate it from its creator. In listening to Askol'dov, one hears at least two distinct voices: that of a confident, uncompromising first-time director in his confrontation with the system; and the

1

bitter though measured maker of only a single film, who twenty years later remembers, and thus necessarily imagines and reimagines, what he was saying and how he was filming back then. Askol'dov must be understood as a producer of his own mythology not just on-screen, but through these memories as well.

This mythology touches on three main elements: (1) the representation of the Revolution and the Civil War; (2) the portrayal of Jewishness through the characters, locales and images, including allusions to the Holocaust; (3) and the depiction of femininity, especially in relation to Russianness. Like a Renaissance painting, the film presents a two-dimensional space of the poetic symbolic reality and the mimetic historical setting. Askol'dov aims to both recreate the diegetic sounds of war-torn Ukraine of 1920, and invent the non-diegetic sounds of the Revolutionary and Jewish visionary realms. This exchange between the symbolic and the factual, the mythological and the historical, the documentary and the imagined speaks to the film's dialogue, consisting of parody, homage and polemics, with the cinema of the Thaw; the early Soviet cinema of Dziga Vertov (1896–1954), Sergei Eisenstein (1889–1948) and Aleksandr Dovzhenko (1894–1956), which 'has the ability to perceive and project an extant hyper-reality invisible to the human eye' (Wyllie 2003: 25); and the films of Michelangelo Antonioni (1912–2007), which engage in a similar high/low dialectic of the symbolic and the factual.

In one respect, however, *The Commissar* completely falls out of its time's intellectual and artistic terrain, namely in its unmasked approach to Jewishness. With a thematically Jewish centre stage, rather than a sporadic Jewish character or a minor storyline thrown in, *The Commissar* has none of the euphemistic doublespeak in which most of the public discussions of Jewishness in the Soviet Union were conducted. On the one hand, Askol'dov demystifies positively and mimetically the Jewish question; on the other, he offers a powerful mythology of Jewishness or, more precisely, a *poetics* of Jewishness. Askol'dov does much more than represent the Jew on-screen or construct a Jewish type. His poetics of Jewishness construes it as a moral, metaphysical and aesthetic concept, which informs the film's mythopoetic, metapoetic and intertextual visual terrain. He accomplishes something very similar with the character of the commissar, and, unsurprisingly for Soviet cinema, offers a poetics of the Revolution and Russianness. His approach to Jewishness, however, is wholly unique in the Soviet cinematic context. As this book will show, the film's judges were at times able to grasp that, although with destructive consequences for Askol'dov.

ALEKSANDR ASKOL'DOV: BINARY TRAJECTORIES

It is impossible to understand the figure of Aleksandr Askol'dov outside the context of his time and generation. A child of the Stalinist 1930s (born in 1932), he matured during the war with Germany and the post-war attempts during the Thaw to reform the Soviet system from within in the aftermath of Stalin's death in 1953. The arrest of his father, a Civil War commissar and later the manager of one of the largest factories in Kiev, at the peak of repressions in 1937 impacted on Askol'dov for the rest of his life. His mother was arrested shortly thereafter and only released on the eve of the war in 1941. These two lives – his father's and his mother's – and their experiences of death from and survival under terror informed Askol'dov's philosophy and vision. As the Russian film scholar Evgenii Margolit has pointed out, the film-makers of the Thaw made the absences of their fathers, swallowed by either the war or the Gulag, the cornerstone of their world-views (Margolit 2012: 502). There is an element of mystery and obfuscation, however, in Askol'dov's take on his father's shadow. The son of a Jewish father (born Iakov Kalmanovich, he later took on the pseudonym Askol'dov) from the Belorussian *shtetl* of Lutsk, and a Russian mother, he kept his father's Jewish origins a secret. Moreover, the fact that an 'ethnic Russian' made the only Soviet film about Jews became a crucial part of the reception of *The Commissar*. If on-screen Askol'dov unapologetically did away with the Soviet erasure of Jews, in life he chose a more circuitous path. This conundrum, as I will suggest, is central to his later self-fashioning and the philosophy of his film.[1]

Two binary trajectories run through Askol'dov's biography prior to his work on *The Commissar*: first, the entanglement of the literary and the visual; and second, the life of a dissenter and the career of a Communist Party

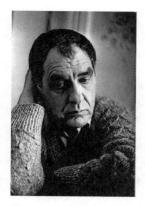

Figure 1: Aleksandr
Askol'dov. Photo courtesy
of Aleksandr Varlamov.

functionary. Of Askol'dov's two loves – cinema and literature – literature was the first. As a student of philology at Moscow State University in the 1950s and later a graduate student there, Askol'dov was fascinated with the figure and work of Mikhail Bulgakov (1891–1940). While writing a dissertation on the theme of the Revolution and the Civil War in Bulgakov's oeuvre, he befriended Bulgakov's widow, helping her in reviving the semi-banned author's work and, most importantly, preparing for publication his masterpiece, the novel *The Master and Margarita*, which finally appeared in 1966. As our subsequent analysis will show, Bulgakov had a clear imprint on *The Commissar*, contributing to its intertextual network. Thus, Askol'dov was fully in tune with the culture and politics of the Thaw and its restorative literary projects. He did so both privately, through his association with Elena Bulgakova, but also publicly; for instance, in 1954 he put his name to the letter in defence of Vladimir Pomerantsev, a critic who famously called for the introduction of 'sincerity' in Soviet literature and the softening of socialist-realist formulaic guidelines.

Askol'dov's career path after leaving the university and abandoning his dissertation is thus peculiar. He became a functionary in the Ministry of Culture, first as a theatre censor and later a chief film censor. There is a saying attributed to the poet Boris Slutskii: 'I want to write for smart Party functionaries' (Grinberg 2013: 294). Askol'dov was the type of Party functionary Slutskii had in mind: enlightened, reform-minded, but at the same time fully devoted to the Soviet cause. The significant question is: how did the work in the highest echelons of Soviet nomenclature impact on Askol'dov's eventual fight with the system to which he belonged?

Askol'dov's philosophy was equally binary, split by the conflicting notions of the Revolution and the Civil War on the one hand, and the Revolution and Stalinism on the other. As a whole, Thaw intellectuals conceived of the Soviet past in two ways: they searched for 'socialism with a human face' as the antithesis to Stalinism, and at the same time romanticized the epoch of the Civil War, with its 'commissars in dusty helmets', to quote from Bulat Okudzhava's cult song 'Sentimental'nyi marsh'/'Sentimental March' (1957). Thus, they strove to harmoniously fuse the idea of the individual with the idea of the Soviet collective. Askol'dov operated within this framework and dramatically modified it, as is apparent not just from *The Commissar*, but also in the significant differences between the film's script – what Askol'dov (2013) called his 'cinematic novel' – and the final cinematic product. It is clear that, while Askol'dov was troubled by the romanticization of Civil War violence, its horror and injustice, he was not at all ready to do away with the apocalyptic 'justice' of the Revolution. Because of this, he stood apart from his cohort by his outspoken devotion to the Revolution as an absolute in Soviet life. This relationship between the war and the Revolution, and the possibility or even desirability of 'socialism with a human face', coupled with the poetics of Jewishness, ultimately constitutes the theme of *The Commissar*.

TRIAL

Reflecting on his time as a theatre censor in the late 1950s, Askol'dov wrote 30 years later:

> It was very clear to me that I was a failure. I didn't defend my thesis, or rather, I abandoned writing it because I lost interest in the topic and didn't want to force myself to work. I had a degree in philology from the university, but the literary profession did not appeal to me and I was not good at it. Clearly, I was no theatre specialist either [...]. I had no plans for the future [...] and did not even try to become anybody.
>
> (Askol'dov 1996: 120)

With this retrospective self-examination, Askol'dov hints at the fact that he truly discovered himself only when he turned to cinema and directing. A seasoned Ministry of Culture bureaucrat, he enrolled in 1964 in a two-year programme for directors and screenwriters at the All-Union State Institute of Cinematography (Vsesoiuznyi gosudarstvennyi institut kinematografii, VGIK) in Moscow. Specifically designed for the more experienced and older candidates, the programme especially attracted those who were not able to find a place in the official Soviet literary or cinematic realm. Thus, Askol'dov was somewhat of an anomaly in this group. Unlike most of the students, whose graduation films were shorts, he proposed directing a feature – *The Commissar*.

There are three main elements that stand out in the censoring of *The Commissar*. The first and most obvious one is the repressive Soviet machine that involved not just the Party bureaucrats who oversaw the film industry, but the practitioners of cinema themselves, Askol'dov's colleagues, sitting in judgment over each other. The second and the third elements are more intricate: Askol'dov's uncompromising character, and the Soviet Jewish psyche and moods. All three pieces of the puzzle are deeply intertwined and embedded in the Aesopian Soviet language of discussions and memos about the film. Reading between the lines of such documents is essential.

The first question is: why was the script approved and allowed to go into production at the Gor'kii studio in Moscow? Elena Stishova (1989: 111–15), who was the first to investigate the *Commissar* files, suggested that it was doomed from the start, as the 'green light' given for the script was largely due to 'ideological negligence' on the part of the studio's script committee. Indeed, some of its members voiced objections early on, in particular regarding Askol'dov's de-romanticized depiction of Commissar Vavilova's brutality. Thus, already at this stage, the judges' accusations did not lack insight. They were cautious about the proposed script precisely because they sensed what it strove to say. It is noteworthy that at this initial stage nothing negative was said about its Jewish side, or the fact that the script was based on the short story by Vasilii Grossman (1905–64), whose novel *Zhizn' i sud'ba/Life and Fate* (first publication in the West 1980) had been seized by the KGB only a few years earlier and banned from publication. On the contrary, the script was criticized for not being completely true to Grossman (Stishova 1989: 116). I would propose that its approval was not a fluke for two reasons: the script itself and Askol'dov's tactics.

Notably, the script has been ignored in the extensive literature on *The Commissar*. As our analysis will show, it differed drastically from the finished product. Some of the script's crucial scenes did not find their way into the film or were significantly changed, while, inversely, some of the film's crucial scenes were not included in the script at all. The script – psychological, historical and devoid of apocalypticism – sings to a different tune than the finished film, which is steeped in apocalyptic imagery. While it clearly paved the ground for *The Commissar*, had the film been true to the script in spirit and in letter, it would have been a significantly different work. Whether this speaks to the evolution of Askol'dov's thinking or to his attempts to trick the system and camouflage what he intended to say is hard to answer conclusively. In other respects, however, Askol'dov's tactic is much clearer. Instructed by the committee and Goskino's chief, Aleksei Romanov, to make changes to the script in regard to Vavilova's demeanour and brutality, Askol'dov promised to acquiesce, yet proceeded to shoot the film precisely as he wanted. 'I tricked and lied to everybody (personal communication April 2015)', Askol'dov says today, without explaining, however, whether the script itself, or at least substantial portions of it, were also an attempt to deceive the system.

Figure 2: Production
stills from Svetlana Kim's
publication in *Sovetskii
ekran*.

Prolonged and difficult filming on location in Ukraine took place in the autumn of 1966. Askol'dov planned on wrapping up the production by mid-February 1967, and having the film released later that year to coincide with the 50th anniversary of the October Revolution. Instead, upon completion, it was put on trial. Its Jewish aspect soon took the centre stage here, with a missing link that complicates the story. In April 1967, four months after the film was shown for the first time at the studio to enthusiastic approval (in particular by Askol'dov's mentor at VGIK, the famed director Leonid Trauberg), and five months before the completed film would be denounced by the studio, *Sovetskii ekran*, a glossy film magazine that began its revived run during the Thaw, published a piece entitled 'The Commissar: Dedicated to the Revolution', under the rubric 'currently in production' [*idut s"emki*]. Authored by Svetlana Kim, the exposé admiringly recounted the plot of the film and featured photos from the set, as well as excerpts from interviews with the director and the film's two main stars, Nonna Mordiukova and Rolan Bykov. Kim spoke highly of the film's communist fervour – as did Askol'dov – and unabashedly pointed to its preoccupation with Jews through Bykov, who stated in the piece:

The role of Efim Magazannik is of extraordinary interest to me.[2] My new hero is very much unlike those nice, kind, humorous Jews, who have become the staple of our cinema. To play this role, one needs bright colours, sharp lines; I am not afraid to be at times petty and non-pretty. It seems to me that one cannot play this role differently. I love this man, Efim Magazannik, since he is full of life. There is a war going on somewhere, but he lives, works, loves his wife, rears his children, thinks […]. He is a philosopher who has his own dreams.

(Kim 1967: 13)

Not mentioned in any of the existing critical writings on *The Commissar*, the piece confirms that the film was not doomed from the start. Remarkably for a Soviet publication, it does not obfuscate the Jewish aspect, but draws attention to it, arguing for the character's dignity and worthiness as a Jew. Whether the article was merely a fluke that somehow got into print or reflective of the larger moods about Askol'dov's project cannot, of course, be known with any certainty. Perhaps there were voices within the film community that were interested in legitimizing, at least for once, a Jewish presence on the Soviet screen and incorporating it into the mythology of the Civil War.[3] This did not happen, as history took a very different turn.

A key reason often cited for the destruction of the film is timing. In June 1967 the Arab States, fully supported by the Soviets, launched an assault on Israel and were swiftly defeated by the Jewish state in only six days. There is no doubt that the Six-Day War led to the resurgence of official anti-Semitism, now masked as anti-Zionism, in the Soviet Union, although its effect on the Soviet Jewish psyche and the image of the Jew in the unofficial Soviet context was much more intricate. The Israeli victory in the war made Jews the talk of the day. The saying that came out of it in the Soviet Union was 'Do not beat the Jews but beat like the Jews'. According to a definitive study of the era, 'The Six-Day War completed the process of the "manifestation" of Jews in Soviet society. The enthusiasm generated by the Israeli victory made anti-Semitism no longer relevant. On the contrary, Jews became fashionable, which was immediately reflected in the popular jokes' (Vail' and Genis 1988: 275). As pointed out by Aleksandr Voronel' (2007), one of the major Soviet Jewish dissident intellectuals, for the intelligentsia, increasingly sceptical of the authorities at large, the Six-Day War and the Soviet portrayal of Israel as the arch enemy put the Jews at the vanguard of the anti-regime thinking and movement. To be a Jew became a way out of the system, which resulted in the subsequent massive Jewish emigration from the USSR.

This is what was in the air when Askol'dov completed *The Commissar* in August 1967. Clearly the studio bureaucrats were following the unspoken Party line of delegitimizing anything Jewish and disguising any anti-Semitic measure as anti-Zionism, but important also is the response of some Jewish critics of the film. Most notable among them is the film-maker Leonid Trauberg, Askol'dov's mentor and a victim of Stalin's post-war anti-Semitic campaigns. In January 1967, Trauberg commented on *The Commissar* during a meeting at the studio: 'Overall I love the film' (Stishova 1989: 116). In August 1967, two months after the Six-Day War, he proclaimed at the discussion of the finished film, 'I want to see a film about a commissar, I don't need a film about the sad fate of the Jewish people' (1989: 117). As our analysis will show, a central if not dominant element of Askol'dov's poetics of Jewishness would be the presentation of the Jew as a victim, perpetually residing in the realm of ruins and death, which he links directly with the Holocaust – a practically taboo topic in the Soviet Union. While *The Commissar* draws upon and enlarges the lachrymose trope of interpreting Jewish history, the image of the Jew resulting from the Israeli victory contradicted and even smashed it. As pointed out by Yakov Ro'i (2008: 257), 'it became evident to Soviet Jews that they did not belong solely to a hapless persecuted people, but to one that occupied a major place in global affairs'. Thus, it would be one-sided to see Trauberg's statement merely as an expression of fear or conformism. On the contrary, perhaps his opposition to the film's depiction of the eternally 'sad' Jew derived from his newly-found Jewish pride and self-consciousness. A year later, in January 1968, Trauberg attempted to salvage the film, which he called 'interesting and brilliant', by proposing a list of changes to be made, including lessening the 'caricatural' side of the Jewish protagonist's character (Troianovskii and Fomin 1998: 278). Once again, the desire to save the film merged with the desire to please the authorities, but also to modify Askol'dov's take on the Jew. The regime, however, was no longer interested in having any Jews in films at all. Romanov privately promised Askol'dov that the film could be released if its Jewish characters were changed to Tatars and the Holocaust scene deleted (Venediktov 2001).

In July 1968, on Romanov's order, the film was completely banned from release, despite opposition from other major directors, such as Sergei Gerasimov and Mikhail Romm, while any cuts proposed earlier were deemed insufficient and impractical (Troianovskii and Fomin 1998: 280–81). The film was 'put on the shelf' and one copy of it preserved, with some parts in disembodied fragments. Askol'dov, like Joseph Brodsky, was tried for social

parasitism and his Party membership revoked.[4] He would spend the next twenty years doing odd jobs, including making a couple of documentaries and directing pop music shows.[5] Askol'dov's stance was uncompromising. A former functionary of the system, he harboured an absolute belief not only in the legitimacy and rightness of his vision, but also its rightful place within permissible Soviet discourse. Possessed of admirable tenacity and naiveté, he failed to realize what became apparent to the film's 'judges'. With its portrayal of the Revolution's apocalypticism – what they called 'dehumanizing' and 'de-heroizing' the Revolution – and the equal weight given to the Jewish and Bolshevik poles of the story – what they identified as 'dangerous ethnocentrism' – the film ceased to operate within the bounds of this discourse. Indeed, *The Commissar* offered an alternative to it.

To a very significant and revealing extent, *The Commissar* contradicted the very premise of ideologically unorthodox Soviet cinema. According to the Russian film theorist Oleg Aronson:

> Thus, when we raise the question about the unique specificity of Soviet cinema, which allows us to speak of it as a phenomenon not only in the context of the history of Soviet cinema but also in the context of the history of world cinema, it is imperative to consider the impact on and even the education of the audience, which presupposed censorship prior to the act of viewing and thus included in the process of viewing some additional images, along with the existing visual aesthetics and genre conventions [...]. In this sense censorship in cinema in terms of how it existed under the Soviet regime possessed (despite all its ugliness) one very valuable quality: it imbued absences with positivity.

> (Aronson 2001)

Thus, Soviet film-makers of the Thaw assumed as a matter of principle that their films would contain meaningful absences, silences, hints and suggestions which would force or invite the viewer to fill in the blanks. By refusing to succumb to censorship, Askol'dov was changing the rules of the game. Instead of meaningful absences, he offered meaningful presences and the non-euphemistic Jew. Undoubtedly complex and open to interpretation, but absolutely direct and explicit in what it wanted to say and how it said it, *The Commissar* would have struck a blow to the very fabric of the liberal Soviet intelligentsia's compromise with the regime had it been released in 1967. In this regard it differed both from the other films that were banned at the end of the Thaw, and a number of other daring films about the Civil War released at the end of the 1960s.[6] As the book's final chapter will elucidate, when the film would be finally released during perestroika, these rules would indeed change, while the question of presences and absences would acquire new dimensions, albeit still echoing the old ones.

Chapter 2
<u>Literary sources</u>

INTERTEXTUAL FRAMEWORK

The Commissar is a deeply intertextual film, whose mythological and aesthetic richness can be grasped only through uncovering its complicated relationship with a network of diverse literary sources. Using Gérard Genette's (1997: 1–7) classification from *Palimpsests*, I divide *The Commissar*'s sources into intertexts (quotation and allusion), metatexts (commentary and allusion) and paratexts ('secondary signals', such as titles and pieces of the production history and reception). All three are intertwined and form a fascinating case of a hermeneutic film (i.e. a cinematic work that functions through inserting itself into a number of literary traditions while simultaneously commenting upon them). As suggested by Mikhail Iampolski, intertextuality may be central to artistic thinking, but it hardly simplifies the process of interpretation:

> [I]ntertextuality, then, while resolving certain contradictions within the text, at the same time creates others that are in fact irresolvable. The intertext functions as the resolution of some (resolvable) contradictions even as it creates others that are irresolvable. Understanding is thus accompanied by the appearance of a mystery. From this perspective meaning itself can be seen as an act of understanding that is shrouded in mystery.
>
> (Iampolski 1998: 47)

This chapter's goal is to come closer to this mystery.

The Commissar's intertextual matrix is comprised of four main sources: first, the story by Vasilii Grossman, 'V gorode Berdicheve'/'In the Town of Berdichev' (1934), which provided the basis for the film's script; second, Mikhail Bulgakov's novel *Belaia gvardiia/White Guard* (1925) and two plays, *Dni Turbinykh/The Days of the Turbins* (1926) and *Beg/Flight* (1937), which all deal with the period of the Civil War; third, Isaak Babel''s *Konarmiia/The Red Cavalry* (1923–25), republished, significantly for our purposes, in 1966; and finally, Pavel Kogan's unfinished narrative poem, 'Pervaia tret''/'The First Third', published in 1965. Thus, Askol'dov's work invokes the three crucial periods of Soviet history – the Revolutionary (Babel' and Bulgakov), the Stalinist (Grossman) and the era of the Great Patriotic War (Kogan) – and comments upon the evolution of the Soviet Jewish writer from Babel' to Kogan. Within this network, Grossman's story functions as an intertext while the rest are metatexts, again keeping in mind the necessary exchange of roles between the two.

The question of sources goes to the very heart of Askol'dov's thinking. To quote Mikhail Iampolski (1998: 47) again: 'What is traditionally considered a quote may end up not being one, while what is not traditionally seen as a quote may well be one'. Hence a quote is 'a fragment of the text that violates its linear development and derives the motivation that integrates it into the text from outside the text itself' (1998: 47). The same is true, I maintain,

of source material when it comes to film. Thus, 'In the Town of Berdichev', while an obvious intertextual starting place for *The Commissar*, does not consistently function as its source, whereas the metatexts unexpectedly begin to fulfil that role, breaking open the film's intentions, and complicating its linear thematic and philosophic progression. The impetus comes from outside the 'text': Askol'dov's self-fashioning; the literary events of the Thaw, such as the rehabilitation of Bulgakov and Babel'; and the rediscovery of Kogan. The classification of sources holds the key to Askol'dov's ingenuity. The analysis of the film in the next chapter will reveal how these sources impact on and engage with the film's visual and musical texture to form its complete aesthetic.

VASILII GROSSMAN

Completed at the age of 29, 'In the Town of Berdichev' was Grossman's first published piece, appearing in *Literaturnaia gazeta*, the Soviet Union's principal literary and critical review. Curiously, Babel' and Bulgakov particularly admired the story. According to Grossman's friend and biographer, the translator and poet Semen Lipkin (1997: 516), Babel' told him, 'Our Jewish capital [Berdichev] has been seen with new eyes here', while Bulgakov ironically quipped: 'How are we to understand that something truly remarkable got into print?' (1997: 516). The story was republished in the collection of Grossman's stories in 1958, where Askol'dov most likely read it. In 1962, however, Grossman's novel *Life and Fate* was seized by the KGB. Askol'dov claims that Grossman's widow told him about this tragedy right after the writer's death in 1964 (Reynaud 1988: 24). High Party officials overseeing the banning of the film certainly knew of it as well. Thus, two years after his death, Grossman's status as a Soviet writer was deeply shaken. Yet collections of his short stories continued to be republished throughout the 1960s. Most notably, a travelogue about Armenia, 'Dobro vam!'/'Peace unto You', with overtones about the Holocaust, came out in a truncated version in 1967. This status as an entrenched insider and an artist destroyed by the system speaks directly to Askol'dov's own case. Both Grossman and Askol'dov, though belonging to different generations, did not entertain the possibility of working outside the official channels. It is remarkable that Grossman, a renowned novelist of the 1930s and a legendary journalist during World War II, produced the most damning account of Soviet ideology with *Life and Fate*. It is even more remarkable that, having experienced the wrath of censorship with his earlier novel *Za pravoe delo/For the Right Cause* (1952) and his documentary writings on the Holocaust, Grossman believed that *Life and Fate* could be officially accepted. Much like with *The Commissar*, the novel was banned precisely because the executioners grasped its explicit message, which frightened them.

The question that needs to be asked is: what did Askol'dov see in the story when embarking upon the script in 1965? While later, after the film's release, he would always speak admiringly of Grossman, he would do so primarily keeping in mind the author of *Life and Fate*. In regard to 'In the Town of Berdichev', his comments are endearing and at the same time patronizing. He bemoans the story's supposed ideological naiveté and structural simplicity, which he views as a testament to the 1930s – the years he both cherishes as the time of his childhood and abhors as the period of Stalinist terror (Askol'dov 2004a). There is nothing patronizing, however, in how Askol'dov, the intertextual artist, engages with the text. He reproduces not merely its content, but absorbs its very binary structure. While the finished film radically rethinks and reimagines Grossman's key points, the script maintains them.

The bare bones of the short story's plot about a pregnant commissar stationed with a Jewish family are replicated in the film. Grossman presents two contradictory philosophies of history – Jewish and Revolutionary. In doing so, he comments upon the depictions of Jews in Russian literature, the mythology of the Revolution and, most interestingly, tropes emanating from Jewish literature, both scriptural and modern. Tantamount to the centrality of St. Petersburg in Russian literature, Berdichev, a major urban centre of the Pale of Settlement, is the source of one of the main city mythologies of both Yiddish and Russian-Jewish literatures; hence Babel''s identification of it as the 'Jewish capital' in his comment to Lipkin quoted above. Grossman's portrayal of Jewish life, however, draws largely on the representations of Jews in Russian literature, particularly by Anton Chekhov, which would be equally important for Askol'dov. Due to his intertexts and status as a Russian Soviet writer and a Jewish native of Berdichev, Grossman

positions himself toward the Jewish realm both as an insider and an outsider peeking in. His remarks about Jewish history are at times platitudinous, reminiscent again of the more benevolent Jewish stereotypes in Russian literature (for example, 'a prayer as ancient as the Jewish nation'; the 'shaking and trembling grandmother'), while at other times they are quite penetrating. His position toward the Revolutionary mythology is equally complex, derived from the canonical image of the commissar in Soviet literature, and the gulf separating the 1930s from the Revolutionary and Civil War eras.

Grossman expresses a Jewish philosophy of history through the prism of violence and the minutia of daily life (or, to use an untranslatable Russian term, *byt*), as in these passages about the Jewish town's behaviour in the midst of the war:

> The townsfolk were all in their cellars and basements. Their eyes closed, barely conscious, they were holding their breath or letting out moans of fear [...]. The patrol would enter the main square. The horses would prance and snort; the riders would call out to one another in a marvelously simple language, and their leader, delighted by the humility of this conquered town now lying flat on its back, would yell out in a drunken voice, fire a revolver shot into the maw of the silence, and his horse to rear.
> [...]
> And then, pouring in from all sides, would come cavalry and infantry. From one house to another would rush tired dusty men in blue greatcoats – thrifty peasants, good-natured enough yet capable of murder and greedy for the town's hens, boots, and towels.
> [...]
> Everybody knew all this, because the town had already changed hands fourteen times. It had been held by Petlyura, by Denikin, by the Bolsheviks, by Galicians and Poles, by Tyutyunik's brigands and Marusya's brigands, and by the crazy Ninth Regiment that was a law unto itself. And it was the same story each time.
>
> (Grossman 2010: 30–31)

The Bolsheviks are not singled out here as a positive force, while violence against Jews is presented as cyclical, occurring 'each time', where each time can be mapped out onto all of Jewish history. Any outside force is threatening to the Jew: the Jewish protagonist Magazanik prefers the times when no army – Red or White – occupies the town. An agent of the Revolution, Commissar Vavilova succumbs to the Jewish logic and is devoured by *byt*, its cycles of both violence and living, and her own rediscovered femininity. About to give birth and thus enter the cycle of life, she breathes in 'the smell of human life [...] taking a deep breath, as if about to dive deep into a pond' (Grossman 2010: 17). Having grown accustomed to the Jewish smells, she ceases to think. Her symbolically deeply negative (or at the very least ambiguous) absorption by *byt* undercuts the Revolution's messianic promise of a new time as it is usurped by the traditional Jewish time:

> Jews were coming back from the synagogue, their prayer garments rolled up under their arms. In the moonlight the empty marketplace and the little streets and houses seemed beautiful and mysterious. Red Army men in riding breeches, their spurs jingling, were along the brick pavements.
>
> (Grossman 2010: 24)

The 'Red Army men' are seduced by their surroundings and diverted from the ideological cause. Whether Grossman was familiar with classical Jewish sources or not, the sentiment prevailing in some of them – that the Messiah would only come when Jews would leave behind their family duties – is reflected in Vavilova's abandonment of her child upon rejoining the troops. For Grossman, quotidian and Revolutionary times cannot co-exist, and neither can the Judaic and Revolutionary.

At the end of the story, Vavilova responds to the messianic Bolshevik call by experiencing an epiphany that lifts her out of the Jewish swamp:

Marching along the broad empty street [...] was a column of young Bolshevik cadets. 'Ma-ay the re-ed banner embo-ody the workers' ide-e-als,' they sang [...]. Vavilova gazed at them. And suddenly it came back to her: Red Square, vast as ever, and several thousand workers who had volunteered for the front, thronging around a wooden platform that had been knocked together in a hurry. A bald man, gesticulating with his cloth cap, was addressing them. Vavilova was standing not far from him.
[...]
She was so agitated that she could not take in half of what he said, even though, apart from not quite being able to roll his *r*'s, he had a clear voice. The people standing beside her were almost gasping as they listened. An old man in a padded jacket was crying.
[...]
Just what had happened to her on that square, beneath the dark walls, she did not know [...]. Looking at the faces of the singing cadets, she lived through once again what she had lived through two years before.
(Grossman 2010: 31–32)

In Graham Roberts' (2005: 94) provocative reading, Lenin is 'silenced' because 'the Party and its worldview is decentred, marginalized and ultimately silenced by Grossman in favour of other, "centrifugal discourses" in what is a deceptively subversive piece of writing'. I would propose, however, that Lenin is silent because Vavilova is in a messianic delirium, with her mind still clouded by motherly concerns and Jewish logic that, unable to decipher the cosmic signs, does not differentiate between the Bolsheviks and the White General Denikin. His silence also carries an erotic dimension, since the father of Vavilova's child, killed on the battlefield, is referred to by her as the 'silent one'.

Yet the mystical experience prevails and resolves her identity crisis; the commissar's duty defeats her responsibility as a mother. A deeply apolitical Magazanik gets to the heart of the matter when he says of Vavilova's leaving: 'There were such people once in the Bund. Real people. Are we people? We are manure'. Beila, his wife, returns him to the world of *byt*: 'Listen, the baby's woken up. You'd better light the Primus – we must heat up some milk'. Thus, it is ultimately not the Jewish realm that 'represents authentic, great, sacred time in contrast to the secular Communists' (Roberts 2005: 93), but the Red one, whose beliefs represent a great, authentic mythology of its own. There is no question that the later Grossman of *Life and Fate*, *Vse techet*/*Everything Flows* (1955–63), 'Sikstinskaia Madonna'/'The Sistine Madonna' (1955) and other pieces would fall on the side of *byt* and life, embodied for him in the aesthetics of Anton Chekhov, rather than the totalitarian absolutism of Stalinism, fascism, and to some extent the canonical Russian novels by Leo Tolstoi, Fiodor Dostoevskii and Ivan Turgenev. Here, in his first story, he is enthralled by the messianic promise of the Revolution, which may have proven to be unfulfillable – the last sentence is the inconclusive 'the cadets disappeared around the turn in the road' – and is thus in need of renewal. The economic normalization of the 1930s and the reacceptance of the material, and even the consumer side of life as a celebrated facet of Soviet progress, perturbed the young Grossman.

When it came to Jewishness, Grossman seems to have felt that any renewal was wishful thinking. If such people were in the Bund [the Jewish labour movement] then Jews clearly had a stake in Revolutionary messianism. The commissar who is supposed to replace Vavilova at the front is the Jew Perelmuter. It is also interesting that Grossman emphasizes Lenin's inability to roll his Rs – the sign of Jewish speech in the Russian context. With the Revolutionary Jews gone, the 'manure' goes on unchanged, its natural and violent cycles of pogroms, markets and synagogues intertwined to ensure the suffering, but also the perpetual continuity of Jewish history, until, from the vantage point of 1930s, it will largely dissolve in the internationalist Soviet family or go underground. Apart from the obvious pejorative meaning, does 'manure' here stand for Jews as wasteful human resources on the fields of history, or as the nurturing source that gives birth to the future? Either option erases the value and singularity of individual life.

Again, the mature Grossman – one of the very first, if not *the* first, to write of the complete erasure of Jews as a people during World War II – would feel very differently about the value of Jewish life. Here, however, the Jews provide the story's local colour (not yet a taboo theme in 1934), whose downfall from previous heroes is strongly suggested. Born in Berdichev, but in a thoroughly acculturated Jewish family, Grossman's early perception of the Jewish *byt* is hardly surprising. It is noteworthy that he gives voice, even if a losing one, to the traditional Jewish view of historical violence. Thus, although not a classic example of socialist realism, the story was an expression of the Revolutionary nostalgia deemed legitimate in the official literary climate of the time.

It is precisely this Revolutionary nostalgia that so appealed to Askol'dov, along with the confrontation between *byt* and the Revolution, Jewish cyclicality and the Revolutionary creation of the new time, which he, unlike Grossman, paints in apocalyptic colours. Significantly, Askol'dov would turn this confrontation not just into the Jewish/Revolutionary polarity, but the Jewish/Russian polarity. His Vavilova would be presented as the very essence of Russia – an element completely lacking in Grossman. Essentializing Vavilova, he would equally essentialize the Jew, fully divorcing him from any involvement in the Revolution.

Yet Askol'dov was also split in his reading of the story. The split reflects his ambivalence about the concept of 'socialism with a human face' – what he called Grossman's un-ideological sense of the value of the individual – and thus the prevalence of the Jewish *byt* over Vavilova's Revolutionary ethic.[7] The differences between the script and the film are a testament to Askol'dov's standing at the interpretive crossroads and the evolution of his ideas, unless one sees the changes purely as a tactic to bypass the censors. Thus, the script does include the scene of the Lenin epiphany that would be replaced in the film by an equally transcendent vision of the Holocaust, breaking the flow of historical time. In Grossman, Vavilova yearns to return to the Revolutionary paradise; in the film, she metamorphoses into the disquieting prophetess/Madonna. The ending with the 'manure' phrase would also be kept in the script, with the telling exclusion of the Bund. The film offers instead Magazanik's rhetorical final quip – 'What a people…' – whose open-endedness and ambiguity ensures the interpretive renewability of Askol'dov's creation. Both the script and the film brutalize Grossman's narrative, but the apocalyticism of the film is practically absent in the script. This apocalypticism comes through Askol'dov's commentary and allusions to his metatexts.

MIKHAIL BULGAKOV

Bulgakov's characters, stranded in the apocalypse of the Civil War, are equally bewildered by the nature of the Bolshevik force. Askol'dov's relation to Bulgakov is similar to his comprehension of Grossman in that Bulgakov's experience as a Soviet writer is as important to him as the texts themselves. In a talk on Bulgakov given in Germany in 1991, Askol'dov compared him with Grossman, claiming that Bulgakov's case should be viewed as the first tragic experiment in Soviet literature (Askoldow 1991: 109). Askol'dov is particularly fascinated by Bulgakov's relationship with Stalin and the tyrant's favourable attitude toward the writer. Hounded by the critics and unable to get his plays staged, Bulgakov received a telephone call from Stalin in 1930 which stopped the persecution. Bulgakov's play *The Days of the Turbins* was staged by the Moscow Art Theatre and became Stalin's favourite, while Bulgakov's new prose, most notably the novel *The Master and Margarita*, and other plays continued to be closed to publication and staging. I would suggest that Askol'dov mapped Bulgakov's complex relationship with the authorities – he calls Bulgakov's life 'the ECG of an artist's life in the Soviet Union' (Askoldow 1991: 109) – onto his own traumatic experiences. He admired Bulgakov's uncompromising stance, expressed in the writer's astoundingly brave letter to the Soviet government in 1930, and, like Bulgakov, was hoping to get a reprieve from his persecutors, perhaps even wishing for his own sympathetic tyrant.

In 1957, when Askol'dov began to read Bulgakov's work voraciously and befriended the writer's widow, Bulgakov's status as an accepted Soviet writer was very precarious. As such, the question of how Askol'dov read Grossman in

1965 must be asked regarding Bulgakov as well. Bulgakov was clearly on Askol'dov's mind when he started working on *The Commissar*. In this respect, *The Commissar* functions as an implicit commentary on Bulgakov, particularly his take on the Civil War. Bulgakov views the Revolution and the war as apocalyptic and destructive in nature on the one hand, and utterly pointless on the other. The opening of the novel *White Guard* sets the apocalyptic stage:

> Great was the year and terrible the Year of Our Lord 1918, the second since the revolution had begun. Sun had been abundant in the summer, snow in the winter, and two stars had risen particularly high in the sky: Venus, the Evening Star, and Mars, red and quivering.
>
> (Bulgakov 2008: 3)

Bulgakov despises apocalypticism in history. In a letter to the Soviet government he describes his 'deep scepticism with regard to the revolutionary process taking place in my backward country and, counterposed to it, my love for Great Evolution' as the fundamental 'feature of my creativity' (Milne 1990: 268–74).

Askol'dov borrows this apocalyptic dimension of the Revolution wholesale, but radically revises it. He does so by separating the Revolution from the Civil War: the former an apocalyptic and brutal, but also pure and grandiose, event that will (or at least may) lead to the bright new era; the latter a perversion of it, meaningless in its violence. Askol'dov's love is for the Great Revolution, not Great Evolution. *The Commissar* presents history either apocalyptically or cyclically, but not evolutionarily. For Askol'dov, there were no winners in the Civil War and everyone was defeated.[8] This is again very similar to Bulgakov's philosophy, where both sides – the Reds and the Whites – are presented 'dispassionately' and equally tragically. But if for Bulgakov the main tragedy of the Revolution is in its destruction of the Russian intelligentsia and hence great Russian culture, for Askol'dov the issue is the Revolution's unfulfilled potential and downfall in the war. *The Commissar* has no interest in the civilized intelligentsia; instead it creates essentialist folk and Revolutionary types, either divorced from civilization or living on its fringes.

Bulgakov roots the horror of the Civil War in the Revolution. To preserve the purity of the Revolution's potential, and in a move completely out of step with Soviet films of the time, Askol'dov leaves the actual war and the Whites outside of the film's narrative and imagery. His commissar, Vavilova, resides in her own solipsistic universe, metaphoric and diegetic. Instead of confronting the Whites, she confronts the Jewish realm. Thus, in the place of hints and silences typical of Thaw cinema, which questions the dogmatic view of the Civil War and gives a voice to the enemy, Askol'dov creates a new mythological reality, which revises the existing iconography and historical footage of the Civil War and the Revolution.

The Commissar functions both as an homage and a polemical commentary on Bulgakov. Askol'dov reveres and revises Bulgakov's Civil War triptych about the defeat and emigration of the Whites: the novel *White Guard*, and the plays *The Days of the Turbins* and *Flight*, based on the novel, the topic of his unfinished dissertation. Both Askol'dov and Bulgakov put the question of flight and return at the centre of their works. In his review of the daring staging of *Flight* in Stalingrad in 1957, Askol'dov (1957: 61) praises the play's 'tragedy and grotesquery', and the blending of reality with the 'imaginary elements' and the 'hyperbolic nightmarish visions' (1957: 66). He singles out the birth scene as the most meaningful one in the play. All of these elements and aesthetic choices are absolutely central to *The Commissar*. Through them, Bulgakov is embedded into the film, confirming that the metatexts function as the film's sources, deeply impacting on its meaning.

The Bulgakov layer also functions as a paratext or a footnote to the film. According to Askol'dov, he chose the shooting location – the ancient Ukrainian city of Kamenets- Podol'skii – partially because of Bulgakov. The choice, as our analysis will show, had tremendous consequences for the film's imagery and philosophy. Bulgakov was stationed in Kamenets as a military doctor in 1916 during World War I. His first wife, Tat'iana Lappa, who accompanied him there, describes in her recorded interviews how they:

[…] took walks in the city, stopped by its notable sites, adored its landscapes in the evening mist that enveloped the fortifications of the town's old fortress, its ancient water towers, staircases and houses. It seems to me that this indescribable panorama impacted in some ways on his description of Jerusalem in *The Master and Margarita*.

(Bulgakov 2011: 585)

In another memoir fragment, Lappa remembers Kamenets as 'beautiful, with its ancient cathedrals and dark mediaeval structures' (Bulgakov 2011: 586). Overall, the town functions as a living entity in *The Commissar*, similarly to the image of Kiev in *White Guard*, referred to by Bulgakov as 'the City'. The image of the city captured and fashioned by Askol'dov is one of the great achievements of his film and a true contribution to world cinema.

Finally, Bulgakov informs *The Commissar* in two other fundamental ways: in its portrayal of Jews and the attention paid to religion. A Soviet intellectual – and thus by definition a religious ignoramus – Askol'dov found his gospel in Bulgakov's oeuvre both literally and figuratively. The film's apocalyptic imagery invokes various biblical tropes and gives birth to its mythology of the Revolution. There is no doubt that Askol'dov, like many other Thaw intellectuals, gathered his biblical knowledge at least partially from Bulgakov's *The Master and Margarita*, with its famous reimagining of the New Testament. Furthermore, the novel's double structure between Soviet Moscow and the Jerusalem of Jesus' time is reflected in the film's symbolic/historical divide.

The son of a Russian Orthodox priest, Bulgakov was deeply ambivalent, at times verging on hostile, about Jewish participation in the Soviet regime. *The Commissar* detaches the Jew from the Revolution and presents him solely as its victim. One of the most powerful episodes in *White Guard* is the murder of a Jew by the Ukrainian nationalists. Though deeply sympathetic, it reinforces the stereotype of the Jew as a fearful character, always at the mercy of others. There is much of Bulgakov's Jew, dying with the final 'Hear, o Israel' prayer on his lips, in Askol'dov's Magazanik.

ISAAK BABEL'

Unlike Bulgakov, who was always sceptical of the Soviet project and became a Soviet writer by default, Babel' (1894– 1940) was enthralled with it, falling into disfavour with the regime in the 1930s and paying for it with his life. Unlike Grossman, whose knowledge of Judaism and Jewish culture was fragmentary, and whose sense of Jewishness was reawakened by the Holocaust, Babel' was steeped in Jewish traditional and folkloric sources, and was an active participant in modernist secular Jewish literature and politics. Similar to Bulgakov, Babel' was one of the writers revived and rehabilitated by the Thaw. His *Selected Works* were published in 1966, around the time when Askol'dov began shooting his film. Furthermore, Babel' was part of what can be termed the 'Soviet Jewish book shelf'. In an atmosphere where Judaism was all but destroyed and the very public presence of the Jew delegitimized, Jewish memory and identity continued to exist and develop through subversive and implicit reading practices. The 'shelf' consisted of a few translated works from Hebrew and widespread translations from German and Yiddish, as well as the Russian books with significant Jewish content (into which category Babel' falls). All officially published and not intended squarely for a Jewish audience (as was the case with the still permissible publications in Yiddish), these volumes gave Soviet Jews an opportunity to assert their separate identity in a safe and yet insubordinate manner.

Had *The Commissar* been released in 1967, it would have become a visual instalment of the Soviet Jewish book shelf, not least because of its implicit association with Babel'. While Askol'dov never publicly commented on the importance of Babel', some of the censors perceptively described *The Commissar* as 'Babel'-like'.[9] Recent writings on the film have suggested the Babel' connection as well: '[t]he film's inspired exalted energy and the overt poetic qualities come from Babel' rather than Grossman' (Margolit 2012: 534). Why and how? How does the Babel' layer operate in the film? Babel' functions as *The Commissar*'s metatextual source in three main ways: (1) philosophical, which includes allusions to and quotes from Babel''s work; (2) biographical, through Askol'dov's self-fashioning; and (3) what might be termed 'accidental'. Thus, as in the case with Grossman and Bulgakov, Askol'dov works out both his

personal and creative searches through the intertext and the writer's experiences. This makes *The Commissar* a coded autobiographical film – Askol'dov's personal *Portrait of the Artist as a Young Man*.

First, the accidental: while the kinship between Babel's panoramas, snippets of Jewish *byt* and Askol'dov's camera eye is striking, I would propose that the effect came about as a result of shooting the film in Kamenets-Podol'skii, which, as I have already noted, Askol'dov partially chose because of its link with Bulgakov. Thus, Askol'dov circuitously arrives at the Babelian imagery and aesthetic by departing from Grossman and his Berdichev, and adding Bulgakov's biography. The ravaged Jewish communities of the Ukrainian regions of Volyn' and Podol'e, with Kamenets at its centre, are the subject of Babel's *The Red Cavalry*. Through its very topography and historical memory, the city inevitably brought Babel' to Askol'dov's imagination, importantly shaping the film's visual texture and helping to generate its poetics of Jewishness.

In *The Commissar*, the Revolution is presented as a redeeming and regenerative apocalyptic force on the one hand, and a corrupted and contaminated one on the other. *The Red Cavalry*, the principal Babel' text for Askol'dov, conceives of it similarly and, like *The Commissar*, contrasts the Revolution with Jewishness. Much more than Grossman, both Babel' and Askol'dov make the confrontation between Jewishness and the Revolution the pivot of their historical and philosophical world-view, albeit for different reasons. Babel' describes the world of Jewish communities tarnished in the military turmoil of 1920 as one of decomposition or near-death. The key depiction occurs in the chapter 'Berestechko', where he contrasts the once rich Jewish life with its current state of decay:

> The Jews live here in large houses painted white or a watery blue. The traditional austerity of this architecture goes back centuries. Behind the houses are sheds […]. The sun never enters these sheds. They are indescribably gloomy and replace our yards. Secret passages lead to cellars and stables. In times of war, people hide in these catacombs from bullets and plunder. Over many days, human refuse and animal dung pile up. Despair and dismay fill the catacombs with an acrid stench and the rotting sourness of excrement. Berestechko stinks inviolably to this day. The smell of rotten herring emanates from everyone. The shtetl reeks in expectations of a new era, and, instead of people, fading reflections of frontier misfortunes wander through it. I had had enough of them by the end of the day, went beyond the edge of the town.
>
> (Babel 2002: 271–72)

The preface to the 1966 edition of Babel's writings was very likely read by Askol'dov. It insightfully points out Babel's (1966: 12) investment in the 'contrasts of the epoch, the collision of the two worlds – the dead, about to be extinguished [Jewish] world and the world of the new and the yet to be born'. As our analysis will show, this encroaching physical magnetism of the Jewish realm and its frightful association with death re-emerges in *The Commissar* in ways both modified and magnified.

The largely autobiographical character of commissar Liutov, the first-person narrator of *The Red Cavalry*, is the key to both Babel's view of Jewishness in the cycle and his personal dilemmas. Askol'dov's mournful attitude toward Jewishness stems from Babel's complicated relationship to it. The enormous difference between Liutov's attitudes toward Jews, Judaism and Jewishness in the text, and Babel's comprehension of them in his diary of 1920 (the basis for *The Red Cavalry*), must be stressed. As Ephraim Sicher (2012: 180) has pointed out, 'Liutov, a fictional persona who embodies a figure of alienation rather different from the diarist on the Soviet-Polish front, should not be confused with the author'. In the cycle, Liutov's Jewishness is never disclosed. However, the reader – and particularly a Jewish reader – can infer it from a number of references, both obvious and concealed: for instance, one can deduce that, when Liutov is visiting the Hasidic rabbi [*tsadik*] in the story 'Rabbi'/The Rabbi', he is conversing with him in Yiddish. The Jewish life as outmoded, decimated, dead, grotesque and incapable of resurrection is Liutov's own perspective. He almost welcomes its demise, disgusted by the Jewish smells and sounds, while giving hints that the Jews have not always been in such existential rags.

The diary, meanwhile, predominantly offers a reverse picture: Babel' mourns the Jewish life and is devastated by the prospects of its end. Most importantly, he appears to be deeply in touch with classical Jewish texts, paradigms and customs:

> Clusters of Jews. Their faces – this is the ghetto, and we are an ancient people, exhausted, but we still have some strength left […]. I wander around endlessly, can't tear myself away, the town was destroyed, is rebuilding, has existed four hundred years, remains of a synagogue […]. An old Jew – I like talking with my own kind – they understand me […]. Dubno synagogues […] you have to have the soul of a Jew to sense what it means. But what does the soul consist of? Can it be that ours is the century in which they perish? […] What a mighty and marvelous fate of a nation existed here.
>
> (Babel 2002: 404–08)

In a sense, the diary presents his return to his historical homeland, the domain of East European Jewish civilization distinct from his home turf of Odessa.

Babel''s hardened view of Jewish life is also mitigated by his version of messianism, which combines the Judaic and communist strands to test if the two can coexist. Key in this regard are the chapters 'Gedali', 'The Rabbi' and 'Syn Rabbi'/'The Rabbi's Son'. In 'Gedali', the eponymous Jew wonders: 'So let's say we say "yes" to the Revolution. But that means that we are supposed to say no to the Sabbath?' He opposes the Revolution, whose inherent violence threatens his faith. Liutov's response is unequivocally simple: 'The Revolution cannot not shoot because it is the Revolution' (Babel 2002: 228). Gedali, a learned Jew who loves the Talmud, the commentaries of Rashi and Maimonides, yearns for the sweet revolution of the Jewish messianic age, while Liutov, a Jew in secret, promulgates the law of the bloody upheaval. Finally, Gedali goes on to his synagogue to pray. Life continues for him, not unlike for Grossman's Jewish 'manure'. Liutov's silence over it conveys not so much an air of agreement and sympathy, as that of ambiguous acquiescence.

In 'The Rabbi', Liutov is invited to a Sabbath evening dinner at the *tsadik*'s house. The rabbi's son, Bratslavskii, is introduced here for the first time. The epitome of holiness and transgression – he looks like Spinoza, the Jewish renegade par excellence; smokes on Sabbath; and is called 'the disobedient son' in reference to the Passover Haggadah – he is the Red/Jewish messiah. The success of Babel''s messianic project hinges on him. In 'The Rabbi's Son', the Judaic is powerfully combined with the communist in the figure of Bratslavskii, who, wounded and dying, is no longer presented as the sinful rebel, but the last prince of the Hasidic dynasty, who, even back then, during the first encounter with Liutov, was already secretly in the Communist Party.

Famously, Liutov collects the belongings of Bratslavskii's trunk, where the sacred artefacts of both communist and Judaic beliefs are chaotically intermixed: 'Portraits of Lenin and Maimonides lay side by side – the gnarled steel of Lenin's skull and the listless silk of Maimonides portrait […] crooked lines of Ancient Hebrew verse huddled in the margins of Communist pamphlets' (Babel 2002: 332). It is Liutov who throws all of these objects together in a bundle, thus signalling that at the heart of the matter lies Babel''s painstaking efforts to give birth to his own communist-Jewish Messiah, an addendum to classical Jewish messianism. Significantly, the 1966 Soviet preface quotes this passage, again insightfully commenting: 'In this excerpt lies the key to Babel''s comprehension of his epoch, filled with contradictions, irreconcilable notions and radical polarities' (Babel' 1966: 12). The question is: how does Askol'dov absorb these contradictions and translate them into his cinematic vision?

Askol'dov's strategy is complex: on the one hand, it is predicated on erasing the Jewish involvement in the Revolution that had been mythologized not just by Babel', but also by major Soviet Jewish poets, such as Eduard Bagritskii (1895–1934), Mikhail Svetlov (1903–64) and Iosif Utkin (1903–44); on the other hand, it establishes the sad, unchanging essence of Jewish history. Instead of the Jewish Liutov, Askol'dov presents the Russian Vavilova, significantly different from Grossman's character, while his Magazanik becomes a version of Gedali. The confrontation

between the two messianic sides of Jewishness – pro- and anti-Bolshevik – metamorphoses into a clash between the eternal Jewish realm and the alien one of Russianness and the Bolsheviks, each projecting their own apocalyptic energy. This is the most crucial aspect of Askol'dov's mythology which must be understood as a commentary on Babel'.

The link to Babel' suggests a parallel between Askol'dov's erasure of the Revolutionary Jew and his concealment of his own Jewish lineage. Like Liutov, Askol'dov, the son of a Jewish commissar, seems to have left his Jewishness hidden precisely in order to enter the zone of the most intimate parts of his identity and imagination. Furthermore, while he could not have read Babel''s diary when working on the film, he certainly did read it when it was published in 1989. His post-1987 recollections of and reflections on shooting the film in Kamenets combine the Jewish sentiments of the diarist Babel' and the disguised identity of Liutov. In the depictions of Jewish life in Kamenets and other nearby towns that were recorded in interviews, he conflates or even collapses contemporaneity (i.e. the Soviet provinces of the mid-1960s) and Babel''s world of 1920. These depictions, to be discussed in the subsequent chapter, speak to his self-mythologizing and self-fashioning. Reimagining history and facts on the ground, they are an apocryphal addition to the film's paratext. The film's last source brings Askol'dov's intertextual matrix full circle, and hinges on the very idea of the literary quotation on-screen.

PAVEL KOGAN

The question of violence – its portrayal, aestheticization and mythologization – is central to *The Commissar*. The episode of the Magazanik children's play is the most powerful expression of Askol'dov's approach. While it will be analysed in detail in the next chapter, here I will introduce its surprising – indeed, pivotal – intertextual basis. In the scene, Efim's sons play a game during which they attack their sister and her doll; they call the sister a 'Yid' [*zhidovka*], tear off the girl's dress and symbolically rape her. The language used, as well as the feathers flying from the torn duvet, leave no doubt that this is a classical representation of a pogrom against Jews. In fact, in the next scene, Magazanik berates the children, calling them 'pogromists'. The kids imagine themselves not as Red Army soldiers, but most likely as members of Petliura's army of Ukrainian nationalists, featured prominently and derisively in Bulgakov's *White Guard*, who were mainly responsible for the incredibly bloody pogroms that swept through the Ukrainian Pale of Settlement during the Civil War period. Interestingly, while the scene was already in the script, the anti-Semitic slur and the father's labelling of the sons as perpetrators of anti-Jewish violence were not in it. The change points to Askol'dov's intertextual thinking. The scene, I would suggest, fundamentally functions as a quote in the manner in which Iampolski (1998: 31) defines it: 'The quote is a fragment of the text that violates its linear development and derives the motivation that integrates it into the text from outside the text itself'. Indeed, the episode comes out of nowhere and is shocking in its unexpectedness. Earlier in the film, one of the boys was 'shooting' at the doll, but nothing foreshadowed the sibling savagery with such anti-Semitic overtones.

The motivation that integrates it into the film comes from Pavel Kogan's unfinished narrative poem, 'The First Third', which he was writing during 1939–41, and which was published in 1965 in the hefty volume, *Sovetskie poety, pavshie na Velikoi Otechestvennoi Voine/Soviet Poets Who Perished during the Great Patriotic War*. Kogan volunteered for the front despite his asthma, enlisted in a reconnaissance unit and was killed in 1942, becoming a legendary figure for the Thaw intellectuals. His lines 'Since childhood, I never liked ovals / Since childhood, I only drew angles' were the generation's motto. Historian Yuri Slezkine describes him as the most representative figure of the new generation of Soviet Jews, who fully bought into the Soviet project to become the new Soviet intelligentsia. He calls him 'the uncontested prophet of the generation', while 'The First Third' is 'his generation's *Eugene Onegin*' (Slezkine 2006: 231). Kogan's generation (or rather cohort) at the Moscow Institute of Philosophy, Literature and History, which included, among others, the poets Boris Slutskii, David Samoilov and Sergei Narovchatov, initiated a lyrical revolution in Soviet poetry in the late 1930s, which achieved its full potential after the surviving poets came back from the front and began to write in earnest.

Born in a Jewish family in Kiev in 1918, very little is in fact known about Kogan, especially regarding his Jewishness. His unfinished poem suggests some of the crucial answers. It tells of two friends, 'a pragmatist and an idealist'. In a key section, the more central character, Vladimir Rogov, who – had the poem been finished probably would have emerged as the true new Soviet man – recalls his childhood. In a kindergarten, a nanny orders children to arrange their dolls in a circle and destroy them, for the dolls in this game represent the bourgeoisie. The massacre of the dolls ensues. When the poem's protagonist imagines that his doll's brains start to leak while blood pours out of her eyes, he takes pity on the doll:

> At first the dolls were beaten up properly,
> and those that fell were not struck,
> But the pathos of this causeless slaughter
> Began to heat up.
> They hit as if the dolls were gods, or apostles,
> Or Christopher Columbus' mother,
> and out of nowhere smashed the table
> just in order to break stuff.
> Volodia did the same. With full force
> He gouged out the doll's right eye,
> but suddenly under his heart there struck
> a crooked rusty needle.
> And it seemed that out of the doll's
> eye, the brains, like meat jelly, crawled
> while her curls filled with blood,
> and there began to stink of dead flesh,
> of skulls, of saucers,
> as the heads were crushed
> not by a little revolution,
> but by an underestimated pogrom.
> Oh, the shame of it and the wish to vanish,
> the wish not to hear and not to be,
> as if he were so dirty,
> and needed to be washed a lot with soap.
> He dropped his stick and began to cry,
> went aside, sat down,
> and did not bother anyone.
> Aunt Nadia, though, told everyone
> that he was a shoddy young Communist,
> simply a deceitful egoist,
> as well as a spoiled child
> and a bourgeois humanitarian.

(Usok 1965: 306; my translation)

After Rogov returns home and tells his mother of the incident, she calls her friend and lashes out against the nanny. The boy turns against the mother, whom he calls a 'bourgeois' [*burzhui*], but, Kogan adds, 'he lied'. His outburst against the mother is a cover-up; his class-consciousness is false. What does it mean that a 'small

revolution' transforms into an 'underestimated pogrom'? Kogan's choice of the word 'pogrom' should not be overlooked.

'Pogrom' in Russian is not simply violence: it is uniquely violence against Jews. Kogan's explicit imagery, redolent of the destruction tropes in modern Jewish verse, confirms this, as the 'pogrom' is embedded into the Revolutionary project – is this not what the poem suggests? It is 'underestimated' because the Revolution's naked, disgusting violence – an example of the 'banality of evil' – was mistaken for a grand project where violence is the expression of existential necessity. What prompted him to compose these lines? Perhaps the grand Revolution remains untouched – it is the 'aunts Nadia' who are to blame: 'Eh, aunt Nadia, aunt Nadia / nicknamed "the labour class" / now three times a day / I meet you in the crowd' (Usok 1965: 306). Grossman of the 1930s would have agreed with this interpretation. Perhaps Kogan witnessed the increase in anti-Semitic sentiments on the eve of war; yet he places the episode in the early 1920s, and thus establishes the link between the Revolutionary era and the eventual fate of the Jews.

There is no question: one need only skim through his poems to understand that he, not unlike Grossman in 'In the Town of Berdichev', was overcome by the messianic potential of the Revolutionary project, which he very much saw as a Russian one. But the lines about a pogrom signal Kogan's nuanced Jewish sensibility. Clearly his parents, Kievan Jews, knew what pogroms meant only too well. We need to consider that one of Kogan's idols was the poet Eduard Bagritskii, who, like Babel', envisioned a fusion of the Jewish and communist messianic mythologies. Significantly, Boris Slutskii's 1960s poetic eulogy of Kogan links his death with the line 'Kogan's been killed' ['*Kogana ubilo…*'] from Bagritskii's narrative poem 'Duma pro Opanasa'/'Thought about Opanas' (Slutskii 1991: 203–05). Thus, Slutskii not only links his friend with Bagritskii's character – Commissar Kogan, the epitome of Jewish involvement in the Revolution – but intertextually also points to Kogan's Jewishness.

One can only speculate about what Askol'dov knew or sensed about Kogan's Jewishness, although there is no doubt that he knew Kogan's verse well. The affinity between his scene and Kogan's lines is remarkable, turning the scene into a quote. The doll imagery unites the poem, the script and the film, thereby unlocking its mystery. The kids' game acquires a double meaning: from the imitation of the anti-Jewish Ukrainian violence to the Revolution's implication in it. The Kogan intertext establishes that *The Commissar* problematizes and complicates the ideal of the Revolution precisely because of the destruction it brought to the Jewish doorstep. The grand apocalypticism of the new era metamorphoses into the traditional historical hatred of the Jew. Babel''s diary conveys a similar idea. The fact that it is the Jewish children who symbolically engage in this anti-Jewish violence touches on Askol'dov's commentary on the Jewish psyche and body, as the analysis section of this book will show.

Finally, the trajectory from Babel' to Grossman to Kogan speaks to the manifestation of Jewishness in Russian and Soviet literature. From Babel''s immersion in the Jewish cultural and textual universe, to Grossman's largely stereotypical depictions of Jewish life (with hints at larger Jewish tropes), to Kogan's only one word, very loaded in meaning, the Jew disappears. The fact that it reappears so vividly and explicitly in *The Commissar* at the intersection of these diverse intertexts and sources speaks to Askol'dov's daring, clarity of purpose and hermeneutic depth.

Chapter 3
Film analysis

The Commissar is shot in widescreen black-and-white, which imbues it with an aura that is both documentarian and serene. The red colour was added when the film was reconstructed in 1987. It appears only once, at the very beginning, when the title 'Commissar' splashes across the screen in red, invoking the blood spilled during the Revolutionary and Civil War eras, as well as the Bolshevik mythology. As the titles roll across the screen, resembling a mediaeval script, we see a pastoral setting, foggy, with disparate shabby trees. The setting resembles iconic depictions of the Gethsemane garden in Jerusalem, where Christ was arrested by the Roman soldiers and led to the crucifixion. Importantly, the scene appears in Bulgakov's *The Master and Margarita*. The Gospel allusion is made explicit by the statue of a mournful Madonna situated in the foreground. The red title 'Commissar' is positioned right across it, thus establishing the link between – if not yet equating – the two figures: the commissar and the Madonna. The non-diegetic sound is a Russian folk lullaby sung by a woman, thus adding a specifically Russian national dimension to the Madonna trope.

As the camera pans over the landscape, it locates a procession of slowly moving soldiers – some walking, but most on horses – at the other end of the field, the first of the film's three main processions. The camera leaves them in the background and moves in on the face of the Madonna statue. With its mournful features now in sharp focus, we see that she is holding a memorial candle. Importantly for the later, crucial scene, the Madonna looks directly at the audience. The soldiers pay no attention to her. It seems that they and she reside in two separate dimensions, not just earthly and divine, but also historical and symbolic. Yet, as she evokes the Russian Orthodox depictions of Mary, she is embedded into the historical realm and grieves over it. Childless, she is the era's patron saint.

The scene exudes a feeling of peaceful emptiness. This emptiness is carried over into the next shot, where it acquires, however, a violent and eerie dimension. A lonely rider – a young boy (Vladimir Donilin) – approaches the town lying below, seen in the distance from the south. The title in pre-Revolutionary Russian orthography – 'Based on the short story by Vas. Grossman "In the Town of Berdichev"' – cuts across the screen. As we have established, it is significant that the city in the distance is not Berdichev, but Kamenets-Podol'skii, located in the south-west of Ukraine, with its fortress dating back to the twelfth century and the mediaeval streets of the Old Town scattered on a rocky island above the Smotrich' River. It has been governed by many people throughout its long history – Ottomans, Poles, Russians and Ukrainians – and was one of the focal points of Jewish life in the region. In 1919 it was the capital of the short-lived independent Ukrainian Republic. As if foreshadowing the importance of the city for *The Commissar*, the major Russian formalist critic and writer Yurii Tynianov, who vacationed in Kamenets in 1931, described it as:

> [...] hunched, ancient, where one can still feel the Ottomans [...]. The distant and near history of Kamenets-Podol'skii is capable of bringing to life many a historical novel, since the very nature of the city is such that here, as if on some magical ground, many an epochal work can be woven.

(Sikora 2010: 532)

In *The Commissar*, the city – the Jewish realm – is situated in a geographical underworld. Parts of Kamenets are indeed based in the canyon of the river, an 'urban cellar'. From these very first shots, the city belongs to the 'lower depths' – the ravine – with the Red Army looking in from the hilltops. As described by one Ukrainian writer, 'Kamenets, when viewed from afar, is situated in a valley, but nearing the city you find that it is located on a hill' (Viniukov 1988: 110). This peculiar topographic dimension contributes to the film's symbolic high/mimetic low polarity.

The rider gallops over the ancient cobblestones and passes through an arch of the northern seventeenth-century Wind Gates, dominated by the Stefan Batory Tower.[10] Arches, as we shall see, will be the key visual trope in the film. He continues along the centuries-old Tatarskaia (Tatar) Street, which embodies the town's complete desolation. Everything in it – boarded-up windows, a house fence fissured with bullet holes, decrepit buildings – recall Bulgakov's wife's description of Kamenets' 'dark mediaeval structures' – indicate that it has been emptied of life as a result of a cataclysm. The viewer does not get a sense that its inhabitants are hiding, but that they simply have vanished. The scene's desolation is apocalyptic. The film's score, jumpy and filled with foreboding, is now heard for the first time. The young Soviet avant-garde composer Alfred Schnittke (1934–98) wrote it, trying his hand at composing for cinema for the first time. The contrapuntal score is an early example of Schnittke's idea of 'polystylistics' in music, which combines cultural high and low elements, theatricality and solemnity. Schnittke's non-diegetic sounds intensify the scene's apocalyptic aspect and sharply contrast with the earlier comforting smoothness of the lullaby.

The decrepit walls of the mediaeval Dominican Catholic cathedral are captured through an arch of the arcade constructed for the set. As a result, the *mise-en-scène* resembles an icon. The rider enters this sacred space and moves on to a small square, shot at an abandoned spot near the seventeenth-century Piatnitskaia Street. Everything in the square, which will feature throughout the film, is symbolic: a synagogue; a cart with a machine gun [*tachanka*]; a pile of horseshoes; and a white flag of surrender hanging from a window of the town hall, also built for the set. Behind it is the bell tower of the ruined fifteenth-century Armenian church. The boy loads up a rifle, while a Jewish star on the synagogue wall is visible in the background. He wantonly throws away one of the horseshoes – presumably from horses who have been shot – smirks maliciously and fires his rifle into the air. A non-diegetic ringing sound is heard. In a series of disorienting jump cuts, the handheld camera, as if following the flight of the bullet, rapidly switches between the tip of the Dominican cathedral's tower, the cathedral in its entirety, the square's synagogue, and the domes of the Orthodox church of Protection of the Mother of God inserted into the shot. The shot –Askol'dov's and the boy's – literally cuts the heavens and civilization embodied in the layers of the city's history into fragmented pieces.

Is this young rider a harbinger of the new era or of more destruction to come? Is his blast amidst an empty, lifeless town pointless, or does it promulgate the defeat of old religions by the new Bolshevik faith? With his *mise-en-scène*,

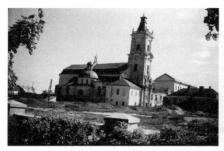

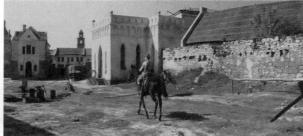

Figure 3: Dominican cathedral. Kamenets-Podol'skii (c. 1960s). Photo courtesy of David Roizen.

Figure 4: A young soldier in the square. Still from the film.

Askol'dov suggests these questions yet does not quite answer them. Overall, this beginning segment functions as an aesthetic and philosophical preamble to the film. Here, Askol'dov thinks as Sergei Eisenstein does in *Ivan Groznyi/ Ivan the Terrible* (*Part I*, 1945; *Part II*, 1948). According to Yuri Tsivian:

> Eisenstein wanted to work on *Ivan* in the way Wagner worked with opera and Joyce with prose [...]: giving form and tension to its surface by means of a vast system of internal correspondences, audiovisual 'rhymes', which is what Eisenstein meant by 'motifs'. A motif is, for him, a thing that recurs – an object [...], a pattern.
>
> (Tsivian 2008: 17–18)

Through these 'internal correspondences', 'Eisenstein counted on our *structural* memory – in this case, on our ability to correlate symmetrical patterns across large spaces of time' (Tsivian 2008: 71; emphasis in original).

Askol'dov establishes a similar set of motifs – arches, horses, processions, religious structures and musical leitmotifs – and counts on the viewer to recall their symbolism whenever they re-emerge. As in Eisenstein's case, this symbolism is continuous and at the same time disrupted, since it is the tension growing between the motifs and within each motif that interests Askol'dov.

The main tension in the preamble is between the force of the Revolution – the Red Army – as harmoniously contiguous with nature and history, yet totally separate from them and antagonistic. This contradiction is manifested in the symbolic/physical polarity of the 'audiovisual rhymes', where the objects appear simultaneously as though part of some apocryphal scripture and documentary footage. Notably, a similar discord is present in Michelangelo Antonioni's films, which deeply impacted on Soviet film-makers, as well as in Andrei Tarkovskii's work. At the same time, the main imagery of the beginning – horses, carts with machine guns, soldiers – is completely in tune with practically all the depictions of the Civil War on the Soviet screen, from the canonical *Chapaev* (Vasil'ev Brothers, 1934) to the films of the 1960s. According to Margolit (2012: 491), these films' attempts at historical authenticity [*realistichnost'*] and attention to detail actually produced myths masked as documents. It is *The Commissar*'s genuinely apocalyptic atmosphere, marked by sheer cosmic emptiness rather than the destruction caused by war, and its dwelling on religion – most importantly the synagogue – that sets it apart from these other works.[11] Askol'dov has the synagogue, built for the set and modelled on the fortified stone synagogues of the Podol'e region, next to the Dominican cathedral, which implies their common fate. Notably, there is a similar symbolic proximity between church and the synagogue in the classic of Yiddish literature, I. L. Peretz's play *A Night in the Old Market Place* (1907), where the setting is equally apocalyptic and death-like.

The preamble also illustrates the shifts in Askol'dov's thinking. In the script, where it is presented almost identically on the surface, there are a number of significant elements that substantially change the meaning of the scene. First, there is the epigraph: 'To our fathers and mothers, those who perished and those who are alive, dedicated'. The epigraph was mentioned in the article about the film in *Sovetskii ekran* (Kim 1967), which suggests that it was removed in 1987. While the 'perished' may imply those who died during the purges (as Askol'dov's father did), it mainly stands as a glorious reminder of the Civil War heroes. The Madonna statue is absent from the script and, while the town is empty, it is also clear that it is still inhabited by people. Most importantly, while the synagogue structure on-screen is decrepit and crumbling (as is every other building), in the script it has just been repainted. Thus, Askol'dov moves from portraying Jewish life as under attack but still living and growing (as it also appears in Grossman's story) to it being emptied out. Overall, unlike in the script, religion in the film has a deeply symbolic role but is never presented as a vital daily force. Finally, there is nothing ominous about the lonely rider figure in the script. Still a victor over the defeated town, he is endearing and a symbol of beautiful, simple humanity. An agent of the Revolution, he carries none of the potential meaninglessness of the rider's actions on-screen. The next scene brings us closer to Askol'dov's understanding of the relationship between the Revolution and violence.

SHOOTING THE DESERTER

Like a pendulum, the camera circles back to the Batory Tower of the Wind Gates. Now a throng of Red Army soldiers noisily rides through the narrow cobbled street of the Old Town, retracing the young horseman's steps. The camera focuses on three riders: two men and a woman in the middle. This trinity adds to the icon allusions employed earlier, and invokes the heroes of old Russian heroic epics [*byliny*]. The camera shifts again to the rest of the soldiers, in particular the cadets in white uniforms, who will reappear at the end of the film, and the horses with their feet rapidly moving as a counterpoint to the pile of horseshoes in the square. The woman gets off the horse and demands a wash in the bathhouse. She is coarse, both physically and verbally. Clad in an army coat and a Cossack hat, she is the commissar. According to Askol'dov, from the very beginning he envisioned Nonna Mordiukova (1925–2008) playing the role. The embodiment of simple Russian beauty, Mordiukova was a rising young star of Soviet cinema, with a few important roles of heroic Soviet women under her belt. Mordiukova said of her character:

> She is as simple as life and heroic as life. First, she is a clumsy creature – a woman in uniform, in whom no one recognizes a woman […]. She forgot that there could be love and family […]. Perhaps she remembers, but this is not the time for such frivolities […]. There is so much of Revolutionary strength and beauty in her! She is a woman-warrior […] a true Communist, fanatically devoted to the Revolution and capable of self-sacrifice.
>
> (Kim 1967: 13)

It would be wrong to perceive these comments as lip service to propaganda. Mordiukova captures her commissar's essence, the product of Askol'dov's vision. On the one hand, Askol'dov follows in the footsteps of the ubiquitous commissar type in Soviet film and literature as the most principled voice of the new ideology; on the other hand, he drastically modifies it.

When Vavilova is introduced in the script for the first time, she is described as a 'bulky, grumpy human being in a simple military coat. This human being's face was dark, rough from the wind, with bulging cheekbones and angry' (Askol'dov 1965: 5). It is impossible to assume from this description that this 'human being' [*chelovek*], notably a masculine noun in Russian, is a woman. Thus, unlike Grossman, Askol'dov does not merely diminish her femininity, but erases it, presenting an asexual or androgynous creature. This 'human being' is alien and frightening, a science-fiction creation. On-screen, it is clear that Vavilova is a woman, but her 'angry' or even 'evil' [*zloi*] masculine features remain. With this coarseness, Askol'dov hearkened back to the character of Maria, a Red Army sniper, in *Sorok-Pervyi/ The Forty-First* (Chukhrai, 1954), one of the most important films of the Thaw, which is based on Boris Lavrenev's story of 1924.[12] Yet the barely literate Maria also exudes exotic femininity, not at all found in Vavilova. The other female commissars – in *Optimisticheskaia tragediia/ The Optimistic Tragedy* (Samsonov, 1963), based on Vsevolod Vishnevskii's play of 1933, or *Sluzhili dva tovarishcha/ Two Comrades Were Serving* (Karelov, 1968) – are intellectuals, who embraced the new ideology. Their femininity is refined and alluring, even if subdued. Thus, a deeply anti-intellectual, largely silent Vavilova is in a category of her own; she is, first and foremost, a mythological Russian type.

The bathhouse scene speaks to her primordial Russianness. As the empty square of the preamble fills with soldiers and horses, and the lonely rider becomes a multitude, Vavilova, nude, washes herself in the traditional Russian bathhouse [*bania*]. We see only her strong hands and broad back, leaving her femininity undisclosed. She splashes hot water on the rocks and beats herself with birch twigs. There is an element of voyeurism here; the viewer enters a forbidden private space. By not letting us see her face, Askol'dov protects his character. The bathhouse is a prominent trope in Russian literature and film, and often represents spiritual purgation. In line with it, Vavilova cleanses herself and prepares for a sacred revolutionary rite.

The bathing of Vavilova is juxtaposed with a pursuit: in a frantic subjective camera shot, a scantily dressed man (Viktor Shakhov) holding a jug in his hands is chased through a narrow alley by a rider on a horse (Leonid Reutov),

who beats the man with a whip. The rider announces that 'Emelin' has been found. Significantly for the film's motifs, this Emelin passes under an arch. The rider gets off the horse and, in a rapid shot, throws him down the stairs into a basement. He announces to Vavilova through the closed door that they have got him. As she dresses in the bathhouse, he – surrounded by soldiers, many of them half nude – washes his head outside at a water tank. The scene is both homoerotic and animalistic, and, as with the bathhouse, another example of symbolic cleansing. Once outside, Vavilova drinks water from the same source. We learn that Emelin is a deserter, who has been hiding at home with his wife. Vavilova orders the basement door to be opened while Emelin, still holding the jug, silently stares at her.

Both are as if hypnotized under each other's gaze. As he ascends the stairs, Vavilova and the other soldiers draw back, visibly frightened. Her speech to him is taken verbatim from the script:

> You've broken the Red Army oath. You've exchanged the Revolution for your woman's food. The Revolution, Emelin, does not avenge, but defends itself. According to our consciousness and for the sake of establishing our bright future, I curse you, Emelin, like a conniving dog.
>
> (Askol'dov 1965: 16)

On-screen she adds, 'I subject you to the trial of the Revolutionary tribunal'. In a manner reminiscent of *Bronenosets Potemkin/The Battleship Potemkin* (Eisenstein, 1925), the camera jump cuts, at a distortive close-up angle, between the soldiers' individual faces, all remorseless – even expressionless – as they stare at Emelin. Vavilova's lips move as she yells, 'Shoot!' But we do not hear her voice, only the jittery notes of Schnittke's score. Time seems to freeze. The camera draws back into a wide shot to present a regiment of soldiers, with the synagogue and the Dominican cathedral suggestively behind them, shooting at Emelin and thus making his execution a fundamentally unequal set-up. In slow motion, Emelin falls on his knees while milk splashes from his partially shattered jar. He lands on his side on the ground and, we presume, dies.

It is hard to underestimate the significance of this scene. Completely absent in Grossman's story, its reading gets at the heart of Askol'dov's understanding of the Revolution. The scene was severely criticized by the censors at the initial stage of the discussion of the script. They branded Vavilova as brutal and 'inhuman'. To have the script approved, Askol'dov agreed to remove it, and have Emelin tried by a tribunal rather than killed on the spot. The censors were right: Vavilova is inhuman and brutal. A natural reaction, especially by a contemporary audience, is to be repulsed by her cruelty. However, one can also be awestruck if her speech about the Revolutionary morality

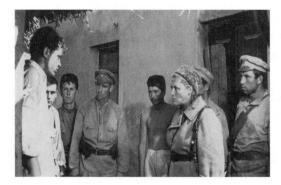

Figure 5: Vavilova
condemns Emelin to death.
Still from the film.

is taken as an impassioned and deep proclamation of faith. For Askol'dov, Vavilova's pronouncements are decidedly not 'ideological clichés' (Monastireva-Ansdell 2006: 240). By saying, 'The Revolution does not avenge, but defends itself', Vavilova is quoting another commissar, Babel''s Liutov, who says to Gedali, 'The Revolution does not shoot, but defends itself'. The censors were frightened by the extreme earnestness with which Askol'dov took on the Revolution and divorced it from conventional morality.

Askol'dov's approach was out of tune with both the official and liberal moods of the time. While such films of the late 1960s as *V ogne broda net/No Path Through Fire* (Panfilov, 1968) and *Two Comrades Were Serving* did not conceal the Revolutionary and Civil War era's ruthlessness, they presented two conflicting and at the same complementary views within the Red Army: merciful and merciless; flexible and uncompromising. Both are united in their heroism and always understood in relation to the actions of the Whites, at times sympathetic, but ultimately eternally murderous and self-destructive. In the Hungarian film *Csillagosok, katonák/The Reds and the Whites* (Jancsó, 1967), co-produced with the USSR and beloved by Askol'dov, the White squadron executes the captured Red soldiers in a manner very similar to the killing of Emelin. In *The Forty-First*, Maria shoots her lover, a White Officer who is her prisoner, to prevent him from fleeing to the enemy, but the act destroys her emotionally. Vavilova's violence, as far as she and her comrades are concerned, does not corrupt her moral fibre.

Askol'dov portrays the Reds as extremely uniform, and existing within a moral vacuum outside of any other contexts. They are separate from the rest of life, and fill the surrounding emptiness with their own bodies and mores. Only one Red cadet tries to defend Emelin, suggesting that his wife is sick; he is immediately shut up. The killing of Emelin is ritualistic, part and parcel of the new Revolutionary religion, what Askol'dov called 'the new Revolutionary moral consciousness born out of blood and of dirt' (Margolit 2012: 533), which prohibits any attachment to the traditional forms and cycles of life. By washing herself beforehand, Vavilova, a Revolutionary priestess, purifies herself of any wrongdoing. Killing Emelin is bloodless: instead of blood, milk – the source of life, soon to flow from Vavilova's own body – is spilled. Emelin dies as a saint, or even as a martyr. Yet it is also crucial for the film's symbolism and aesthetic that Vavilova and her soldiers do not have blood on their hands, thus making Emelin a necessary sacrifice. Silent and with the milk jar always in his hands, he seems to be symbolically privy to and accepting of his fate. There is no question that Askol'dov is horrified by the brutality of the war – it contaminates the humanistic promise of the Revolution – but he is also mesmerized by its force and aestheticizes it. Emelin's death in slow motion brings to mind Jacques Rivette's famous denunciation of the beautiful death of a female concentration camp inmate in Gillo Pontecorvo's *Kapó* (1959):

> In *Kapó,* witness the shot in which Emmanuelle Riva commits suicide and throws herself on the electric barbwire: a man who decides, at that precise point, to have the camera track in and tilt up at the dead body – carefully positioning the raised hand in a corner of the final frame – that man deserves nothing but the most profound contempt.
>
> (Rivette 1961)

I do not suggest that Askol'dov's carefully orchestrated shot of Emelin's bloodless death deserves our contempt, but stress how its overpowering exquisite aesthetic is both morally complex and paramount to understanding his unorthodox historical and political vision.

CONVERSATION WITH THE COMMANDER: PROCESSION TO THE HOUSE

Vavilova is speaking with, or rather being interrogated by, her regiment's commander, played by Vasilii Shukshin – a brilliant director, writer and actor, who would support Askol'dov at the film's 'trial'. Grossman's story begins with

this episode. We learn that Vavilova is carrying a child and that at this stage it is too late to terminate the pregnancy. The commander haughtily laughs at her predicament. It is ironic that he threatens Vavilova with a military tribunal given that she just had a deserter shot, and he symbolically places a few bullets on the table. The complex play on the nature of gender in the previous scenes becomes here much more conventional. Though Vavilova had to fight off sexist jokes earlier, she was at the very helm of the masculine world, and ultimately genderless or androgynous. Having punished Emelin for placing the duty toward his wife above his loyalty to the Revolution, Vavilova herself now enters the zone of the traditionally feminine. It is crucial, however, that she exhibits no remorse for the killing of Emelin, but is distraught over the discovery of her biological nature through pregnancy. The commander, much more explicitly chauvinistic in the story and more sympathetic on-screen, decides to have her stationed with a local family and suggests, as in Grossman's text, that commissar Perelmuter (who we can presume to be a Jew) come in her stead.

The conversation takes place in a large room, with lavish furniture and elaborate candlesticks. Based on the script, we can deduce that it belongs to Ashkenazi, a rich Jew in town. Through the Ashkenazi plotline (absent in the film), Askol'dov presents the diversity of Jewish life in town. The Red Army officer occupying the house instructs Ashkenazi to stop burning his books, which he has been doing to provide heat for his family during winter. In the context of the Holocaust, the image of a Jew burning books is shocking, as Askol'dov clearly knew. When *The Commissar* was banned in 1968, Askol'dov was told that parts of his film footage were being burned at the Gor'kii studio. Askol'dov wrote a letter to Mikhail Suslov, chief ideologue of the regime, asking him to put a stop to it and reminding him that, while the Nazis scorched books, the Soviets were now doing the same to cinema. Suslov responded with the order to stop the 'ugly deed (personal communication April 2015)'.

The telling and symbolic disparity between the script's and the film's depiction of the town's Jewish milieu continues in the next scene. In the script, as Vavilova walks to her new residence, 'Jews solemnly march to a synagogue, carrying prayer clothes in their handbags' (Askol'dov 1965: 24). The script features a Jewish pauper, intoning – Askol'dov (1965: 25) quotes Grossman's hackneyed phrase – 'a prayer as ancient as the Jewish people'. On-screen, he becomes a suggestively Jewish wanderer, and is played by the film's cinematographer, Valerii Ginzburg (1925–98), as a mythical figure sitting amidst an empty street and sharpening knives. Vavilova, as if arrested, is led to her new residence in a solemn procession of her own, while Schnittke's mournful soundtrack is heard. The town is still eerily empty, with only sporadic signs of life. Going down the hill and down the steep stairs by the fortresses' walls, she is entering the Jewish bottom.

THE JEWISH HOUSEHOLD

When Askol'dov arrived in the Old Town of Kamenets-Podol'skii – the city is divided between old and new sections – he found himself at the corner of Sholem Aleichem Lane and Karl Marx Street (personal communication April 2015). To him, this intersection, named after the father of modern Yiddish literature and the father of communism, respectively, became emblematic of the very essence of his project: the confrontational encounter of the Red and Jewish spheres. In an interview with the local newspaper in 1966, Askol'dov stated about the city: 'Kamenets-Podol'skii is a cinematographic sanctuary […]. In order to find the fitting location for the film we've travelled six and half thousand kilometres (in Belorussia, Moldavia, Lithuania, etc.). Nowhere, did we find a more beautiful place than this' (Demchyk 1966: 4). Rather than replicating Grossman's Berdichev, he was clearly searching for something distinct from the outset. Indeed, as we have established, the city suggests the film's idea and aesthetic in a number of crucial ways: the fortress and the surrounding blocks shape the sacred and archaic visual texture, while the Old Town, perceptually located in the ravine, positions the Jewish realm as belonging in the underworld. As in Michelangelo Antonioni's *L'avventura* (1960), 'the landscape becomes a catalyst that drives the narrative and structures the film's haptical and emotional resonances' (Jazairy 2009: 358).

The cinematographer, Valerii Ginzburg, was deeply disappointed over the initial decision to have Magazanik's house built on the set. He remembers in an interview recorded in 1990:

When we were shooting in Kamenets-Podol'skii, I felt and saw the image of this small city, its stone structure [...]. I tried not to miss the shape of stones: church walls, yard fences, cobbled pavements, and the house of Magazanik, in places painted and in places keeping the coldness of the cobblestones [...]. When I saw where his house would be built, I realized that the authenticity and veracity of the incredible live reality, which had to surround our characters, could not be attained by any artificial means. I began to wander around town and [...] found Magazanik's yard and house: as if enclosed within itself, made of stone, but, most importantly, alive.

(Ermakova 1990: 10)

Ginzburg, one of the most inventive cinematographers of his generation, perceptively touches on the very aesthetic of *The Commissar*: its search for historical documentary authenticity co-exists with the deeply symbolic and metaphorical elements, which ultimately prevail. The symbolic here is not an allegorical representation of an idea, but a separate mythic reality. For the censors, this layered-ness was a sign of the film's compositional failure. The sense of Magazanik's house as both 'self-enclosed and alive' is deeply significant. While the Jewish and Red spheres are very different, they are both insular and fully self-sufficient, constantly stewing in their own juices. Therefore, Magazanik and his household become the essentialized embodiment of Jewishness, rather than a historical representation of the Jewish poor, as is the case in Grossman's story and even Askol'dov's script. Shot in two locations on the ancient Dovga and Kuznetskaia Streets, Magazanik's house, an island, transforms into the locus of Jewishness at the exclusion of other Jewish voices – religious, cultural, political and economic. Magazanik mentions other Jews in town, including the rich Ashkenazi from the script, but in the overall atmosphere of emptiness and invisibility, they, like the Jewish commissar Perelmuter, seem to be superfluous figments of the characters' imagination.

The film's portrayal of the Jewish *byt* is predicated on the same complex and uneasy mix of the ethnographically authentic and the symbolically essentialist, which at times verges on the stereotypical. Like a turn-of-the-twentieth-century collector of folk culture, Ginzburg, along with the film's production designer, Sergei Serebrenikov, surveyed and bought from the locals' furniture, dishes and even sacred paraphernalia – remnants of the once plentiful Jewish life in the city – and placed some of the findings inside the Magazanik house. Yet Askol'dov's true aim was capturing the 'garlic' smell of the Jewish household (personal communication April 2015). In the popular and literary Russian

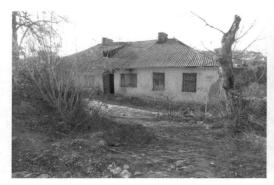

Figure 6: Magazanik's house today. Photo courtesy of David Roizen.

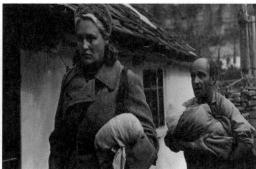

Figure 7: Vavilova and Magazanik: the first meeting. Still from the film.

imagination, garlic is the quintessential Jewish smell. Denoting both stench and longevity, it paints the Jewish realm as both repulsive and attractive. In Grossman's (2010: 17) story, smell plays a paramount role: 'There was nothing the room did not smell of. Paraffin, garlic, sweat, fried goose fat, unwashed linen – the smell of human life, of human habitation'. The passage is also quoted in Askol'dov's script. As a sense of a specifically Jewish nature, smell plays a central role in Russian texts on Jews, including the virulently anti-Semitic ones. In Chekhov's stories, which deeply impressed Grossman (and through him Askol'dov), the manifold Jewish characters are morally complex and at times sympathetic, despite often inhabiting households with the same squalor and odour, especially in 'Step'/'The Steppe' (1888) and 'Skripka Rotshil'da'/'Rothschild's Fiddle' (1894).[13] In the latter, the Jewish character is pejoratively referred to by the gentile protagonist as 'garlic'. But if Magazanik's family is part of the greater diverse whole for Grossman, in Askol'dov's vision it is singular and tantamount to the Jewish spirit at large. Gender occupies here a central place as well. As in the case with Vavilova's world, the Jewish domain is idiosyncratic, resisting the separateness of the feminine and the masculine. The film's Jewish family is hardly an idyll, and cannot be measured by the traditional tastes of what is beautiful and appealing.

As Vavilova enters the Magazanik yard, which almost resembles a cave, she first passes by their oldest daughter (Liuba Kats), whose importance will become clear later. The camera abruptly switches to the other members of the clan absorbed in their activities: first the mother cooking and drying washed clothes, and then the father making something out of tinplate. The mother is strikingly beautiful; the father is diminutive, sweaty and bold. The soldier who escorted Vavilova – she is now standing silent by the yard's gate – announces to Magazanik that she will be stationed with them. His reaction is frenzied. Pacing back and forth and holding his swaddled infant, Magazanik questions the justice of the decision and wonders why the Soviet regime, which is supposed to favour the poor and which they welcomed, is now oppressing him. After the soldier goes inside, Magazanik curses the Bolsheviks. Vavilova's expression as she witnesses the scene is one of both indifference and disgust. Though Magazanik addresses her, she remains silent. Once in the house, where everyone is screaming – the little children and the bickering parents – the scene becomes comical as Magazanik demonstrably removes bedding and a wall clock from their marital bedroom, now Vavilova's quarters. The camera shifts back to the yard, where the three Magazanik boys, probably aged between seven and eight, play war, and the old grandmother (Liudmila Volynskaia) holds an infant, an absent-minded smile on her lips. In accordance with Jewish custom, and indicative of Askol'dov's attention to ethnographic details, her kerchief does not cover her ears. It is significant that the boys pick up a doll, place her against the wall and shoot at it with a toy gun. Thus, Askol'dov establishes his motif that, when repeated, will acquire a new, even darker meaning.

Figure 8: Vavilova's first night at the Magazanik house. Still from the film.

In the next scene, the camera pans through the darkened house over the peacefully sleeping Magazanik family, all together practically in one bed; the walls of the household with the hanging garlic; and the ticking clock thrown on the floor. Though disrupted, their time does not stop. In the next room, Vavilova, whose shadow is distinct on the wall in a film noir manner, cannot sleep. A malicious and mysterious being, she looks out the window and peers into the external emptiness. In the script, there is a bustling romantic nightlife outside at this moment, which again speaks to two very different images of the city presented on the page and on-screen. Finally, she extinguishes the candle – recall the Madonna statue with the candle in the preamble – and falls to sleep on the floor rather than a bed. Her troubled expression indicates that she is consumed by worry and thought. In the script, she will later recall her childhood and youth in the village, which would add to her humanity and rootedness in the cycles of life. In the absence of such memories on-screen, Vavilova remains a creature of the new, alien world, whose relationship to such cycles will always be tenuous and idiosyncratic. The central issue of the film is what kind of a creature Magazanik is. The next scene brings the viewer face to face with him.

MAGAZANIK

Askol'dov's friend, the great director Aleksei German (1938–2013), says about Rolan Bykov (1929–98), who plays Magazanik:

> Rolan is one of the very few people who can be identified by the word 'genius'. If talent is a combination of one's abilities, then Bykov is simply a genius. A genius Russian actor. One can clearly grasp this by seeing him in *Andrei Rublev* […] and *The Commissar*.

(Dolin 2011: 134–35)

Bykov played a humane commander of a gorilla Soviet regiment during World War II in German's *Proverka na dorogakh/Trial on the Road* (1971), whose counterpart is the ruthless commissar, played by Anatolii Solonitsyn (1934–82). Interestingly, in *No Path Through Fire*, Solonitsyn played a humane and philosophical Civil War commissar. In *Trial on the Road*, also released only in 1986, German wanted Bykov to play his character as the embodiment of Russian people [*sygrat' russkii narod*]; in *The Commissar*, Bykov aims to play the eternal Jew.

Like Askol'dov, Bykov, the son of a Civil War hero, also kept his Jewish roots undisclosed. Much more than playing the role, he, a major director in his own right, shaped the character on a par with Askol'dov. In Grossman's story and the script, he is nicknamed 'Tatar', which implies his impiety and perhaps stupidity. The character on-screen is infinitely more complex. Having earlier played the prototypical Russian little man Akakii Akakievich Bashmachkin in Aleksei Batalov's 1959 adaptation of Nikolai Gogol''s 'The Overcoat', and a jester in Tarkovskii's *Andrei Rublev* (1966; released 1973), Bykov incorporated these characters' unbridled folksiness and tragic insignificance into his Magazanik. The legacy of the great Yiddish theatre actor and director Solomon Mikhoels (1890–1948), much revered by Askol'dov, inevitably seeped, at least outwardly, into Bykov's approach and technique. Echoed in Magazanik are the tragic Mikhoels of King Lear, his most famous theatre role; the comedic and grotesque Mikhoels of the film *Evreiskoe schast'e/Jewish Luck* (Granovskii, 1925), whose script was written by Babel'; and Mikhoels the humming *shtetl* Jew who happily embraces the new Soviet order in the film *Vozvrashchenie Natana Bekkera/The Return of Nathan Becker* (Milman and Shpis, 1933). To recall, Bykov emphasized how his character differed from the 'nice, kind, humorous Jews' in Soviet cinema (Kim 1967), who, as he could have added, were few and far between and never explicitly Jewish. In reflecting on his role in the 1990s, he reiterated this thought. He comments that his aim was not to promote either the anti-Semitic stereotype of the Jew, or a no less disingenuous image of the 'good Jew' found, according to him, in the Slovak film *Obchod na korze/The Shop on Main Street* (Kadár and Klos, 1965) (Kim 1967).[14] Instead, his Magazanik was to be a full-bodied patriarch,

fully at home with his inner and outer Jewishness. He is impatient, brassy and clownish. He wears his Jewishness on his sleeve, and exudes what Franz Kafka called in his talk on the Yiddish language 'self-confidence' in being a Jew (Anderson 1989: 266). Hardly expressed religiously, the essentialist and organic Jewishness instructs his entire behaviour and speech, from gestures to curses to anecdotes. Magazanik is an outgrowth of a type or types, but ultimately an original character of a Jew thrown into the whirlwind of history, but always staying within his own solipsistic zone.

At times, however, he verges on a stereotype, particularly to the western and American viewer. Reviewing the film in 1989 and getting a number of facts wrong, Stanley Kauffman bemoaned Bykov's acting:

[Askol'dov] encourages Bykov (who, like this director, is not Jewish) to give a performance that makes my most painful memories of the Yiddish Art Theatre seem like British underplaying. What shrugs, what gestures (always two-handed), what cantorial intonations, what head clutching. It's all well-meant, not caricature, but Bykov, an experienced actor, here uses his experience and memories like a file of recipes, adding ingredients of his own to strengthen the flavors.

(Kauffman 1988: 24)

A number of Soviet Jewish figures around the film seem to have caught on some of these aspects as well. According to Bykov, the rabbi of the Moscow synagogue, who served as the Judaic consultant on the set, wrote a letter to the authorities denouncing the Magazanik character as 'anti-Semitic'. This rabbi was Leyb Levin, a deeply educated and charismatic figure, who visited the United States in 1968 and met in New York with the Lubavitcher Rebbe.[15] Levin was in a precarious position because he needed to please the regime while still cooperating with the KGB to ensure the continuity of some form of Judaic practice in the Soviet Union. Like today's decriers of ethnic stereotypes on-screen, he might have been genuinely displeased with the hardly perfect Magazanik. On the other hand, a number of Jews working at the Gor'kii studio, who fully and successfully functioned within the Soviet system, also pointed out the film's 'anti-Semitic' tendencies.[16] Their unacknowledged fear seems to have been that they too would be perceived as 'Magazaniks'.[16] Exploited by the authorities, their sentiments are reflective not only of the patterns of self-hatred, but also the dynamics of internal and subterranean Jewish politics in the Soviet context; the implicit meanings of 'anti-Semitism'; and the audacity and pitfalls of Askol'dov and Bykov's choices.[17]

Magazanik's vitality, idiosyncrasy and mythological nature flesh out in the morning scene. After he wakes up, seemingly long after his wife and children, he crosses from one room to another and passes by the *mezuzah* without kissing it.[18] It is very likely that Askol'dov didn't know that the *mezuzah* should be kissed, but the irreligious nature of Magazanik's Jewishness is clear. He says 'good morning' to his mother, who is sitting on her bed and, customarily for a woman, reciting a prayer in Yiddish rather than Hebrew, asking God for happiness for her children. The grandmother is the only one in the household who speaks Yiddish and is observant. Obviously Askol'dov could not have the entire film in Yiddish, but he could have given hints that Yiddish was the language of the home, as would have been the historical case. The fact that the parents and the children speak Russian, albeit with a noticeable sing-song Yiddish intonation, not only brings the Magazaniks closer to the later Soviet reality, but also emphasizes their ahistorical nature. The switch of his name from Grossman's Khayim (meaning 'life') to Efim is also reflective of the later Soviet routine change of Jewish names to Russian-sounding ones.

In the film, there is the obsolete Jewishness of their religion, touchingly and patronizingly depicted through the grandmother, and the animated interminable Jewishness of Magazanik. While not observant, Magazanik is an ironic scriptural commentator. He offers to his wife a *midrash* – a rabbinic commentary of a sort – about 'potatoes' that is absent in the script and a variation on a Yiddish folk song: God creates only potatoes on all five days of creation. Magazanik's punchline is: 'Why did he then have to create us on the sixth day?' Why live in the world where the poor have nothing but potatoes to eat? There is something from Sholem-Aleichem's Tevye the Milkman – who constantly

fuses a quotation from the Scripture with his ironic take on it – in Magazanik's parody of the first chapter of Genesis. Unlike Tevye, a literate Jew who takes his arguments with God seriously, Magazanik does not seem to ponder the Almighty in earnest at all.

As he steps out into the courtyard, having cursed Vavilova a *katsapka*, a pejorative term for a Russian woman, he first urinates (quite shockingly for Soviet cinema) and then proceeds to dance while humming a tune. The scene is not in the script and, according to Bykov, was fully designed by him. He touches his face and waves his hands. This is his prayer to the world. While his gestures are stereotypically Jewish, his dance can be seen as a prayer to nature (and thus pantheistic), rather than to the Jewish God for having created the world. Once again, Magazanik's Jewishness goes beyond traditional norms. He is unabashedly at one with nature and outside of any civilization. He does not embody the historical Jewish milieu, diverse in its religious, historical, cultural and political activities, or even the mythology of the *shtetl*, developed in modern Yiddish literature and art. Instead, he distinctively presents the Jew as a noble savage of sorts.

Non-bearded and bareheaded, Efim does not resemble the typical photographic and artistic portrait of the turn-of-the-century Jew. The project of capturing a people's, mainly the Russians', bodily essence was on the minds of other Soviet film-makers, particularly Tarkovskii in *Andrei Rublev*, which had its own troubled production and release history, and repulsed conventional tastes. Yet Bykov's Magazanik is also different. After kissing his wife on the cheek and the baby on the bottom, he proceeds to walk toward the courtyard's exit in an explicitly Chaplinesque manner to amuse them. He plays a tramp and is fully aware of it. Once at the gate, he turns toward the camera, which lingers on his face, and he winks at us. A noble savage turns into an ironic and sophisticated trickster, who knows much more than he lets on, and steps outside of himself.

With Efim off to work to fix broken pots and pans, and the Magazanik household busy with daily activities, Vavilova awakens. Her shadow is still visible on the wall as she begins to dress, unable to clasp her pants because of her growing belly. The camera leaves her and switches to the yard, where the naked children are being bathed by the mother, as a jovial non-diegetic *klezmer*-like soundtrack plays. According to Askol'dov (personal communication April 2015), he could not find any recordings of either modern or traditional Jewish music since they were destroyed by the authorities, and had to rely fully on Schnittke's score to musically capture Jewishness. It does so brilliantly. It should be noted, however, that some Jewish music was available in the USSR. The singer Nekhama Lifshitsaite, who performed in Yiddish and even Hebrew, travelled across the country with her concerts, including in Kamenets-Podol'skii in 1967. Recordings of her songs were specifically made available for western audiences (Khazdan 2012).

The bathing scene is crucial and deeply symbolic. In it, for the first time, the character of the mother is fleshed out. As Lev Anninskii has pointed out, 'Askol'dov's most decisive departure from Grossman's story is visible in her: instead of the almost floating and not at all miniature Beila Magazanik, there appears the refined and exquisite Maria' (Anninskii 1991: 226). The name Maria signals, of course, an allusion to the Gospels and the mother's status as a Madonna. This translation of Jewish terms into recognizably Christian ones, however, does not at all imply the erasure of the intrinsically Jewish. If anything, Askol'dov reminds his viewers that the face of the Madonna [*lik*] is a Jewish face. Maria is played by the Ukrainian actress Raisa Nedashkovskaia (1943–), who was well known for her roles as the forest creature Mavka in the film *Lesnaia pesnia/The Forest Song* (Ivchenko, 1961), and as a telephone operator in the popular Azerbaijani film *Telefonistka/The Telephone Operator* (Seidbeili, 1962). Young, and far from the star status of Bykov and Morduikova, she had a difficult time being accepted by the rest of the crew. The Yiddish intonation in her Russian is overtly conspicuous, transforming it into a cliché. At the same time, she possesses vitality and power. With her character, Askol'dov draws on the trope of Jewish femininity in Russian literature as exotic, mysterious and eternal. The most prominent example of it is the story 'Zhidovka'/'A Yid Woman' (1904) by Aleksandr Kuprin (1870–1938):

> The Jewish woman preserves the spirit and type of her race, carefully carries through the rivers of blood and under the constant threat of violence the sacred fire of her people's genius and will never let it be extinguished [...]. There

is a miracle here, some divine mystery [...] the living riddle, perhaps the most inexplicable and greatest in the history of humanity.

(Kuprin 1971: 357–58)

As part of this mythology of Jewishness, her husband is sickly and cowardly.

While ostensibly the feminine and masculine roles are neatly and traditionally demarcated in the Magazanik family, they are in fact blurred. As the nagging wife type in Yiddish folklore, Maria dominates Efim, and for all intents and purposes is in charge of the household. She is more composed and rational than her husband. Small in stature, fearful and prone to mood swings, Efim is stereotypically feminine, and thus an outgrowth of the largely derogatory image of the feminine Jew from various Russian and European twentieth-century discourses. More importantly, this fluidity between the feminine and the masculine crookedly mirrors the androgynous premise of Vavilova's world.

The bathing scene is as symbolic as Vavilova's earlier washing in the bathhouse. As the three boys (played by Pavlik Levin, Dima Kleiman and Igor' Fishman, who were all from Odessa) are playing and splashing in a narrow basin, one of them yells out, 'I have seven children', imitating Efim. Suddenly the soundtrack stops and instead the diegetic clamour is heard, while Maria's face darkens in terror, intercut with Vavilova lovingly studying her gun in the bedroom. The screeching noise comes from a cart with a machine gun [*tachanka*] passing by the Magazanik children in a continuous tracking shot. A dominant object in the preamble and the overall Soviet symbol of the Civil War, tachanka reappears as a dangerous metonymy of Vavilova's realm. Instead of the children's faces, we see their genitalia – three male and one female – in a close-up shocking for the Soviet screen and uncomfortable for contemporary tastes. The boys' penises are visibly circumcised, an anomaly for the 1960s Soviet Union, where the ritual could have been carried out only rarely and clandestinely. It could not have escaped Askol'dov that seeing a nude Jewish body, especially that of a child, would take on an especially grim dimension in the post-Holocaust world. The blatant phallic magnitude of the *tachanka* opposes the specifically Jewish body, bringing to mind Jean-Luc Godard's famous identification of 'tracking shots' as a moral issue. As with the murder of Emelin, Askol'dov aestheticizes and also eroticizes the violence that the weapon represents. The camera closes in on Maria's now threatening face, as the *tachanka* recedes into the distance. In her determination to stand against the incoming antagonistic force, she mirrors Vavilova's militarism. The non-diegetic church bells imbue the scene with a mythological dimension, while in the script it is devoid of any menace or symbolism.

Askol'dov powerfully presents the Revolutionary might as a threat to Jewishness. Caressing her gun, Vavilova is clearly associated with the *tachanka*. While she may physically reside in the Magazanik house, symbolically and mentally she remains in her own world. Her always visible shadow encapsulates this split between the physical and the symbolic. The scene also illustrates how the film works compositionally. According to Joe Andrew (2007: 34), '*The Commissar* is structured around a series of spatial binary oppositions, open spaces as against enclosed spaces, with each imbued with a range of semantic codes, essentially organized along the lines [...] public: private//male: female//death: life'. Yet, while the Revolutionary and Jewish spheres are set against each other, their internal make-up is heterogeneous rather than binary. The two worlds are juxtaposed, running parallel to each other, and aesthetically united through a chain of the same images, symbols, objects and locales, forming the film's textuality. As an icon or scripture, *The Commissar*'s 'materiality' (Martin 2014: xvii) is two-dimensional, with the mimetic (realist, historical) and psychological register concealing the higher symbolic (timeless) one. While the Jewish and Revolutionary halves interact on the mimetic and psychological levels, they remain perpetually apart and often confrontational on the symbolic one. The next few scenes, leading up to Vavilova giving birth, occur within the peaceful mimetic plane.

VZHIVANIE: ENTERING THE JEWISH LIFE

The camera zooms in on the photograph of an old bearded Jew in a traditional hat that hangs, slightly slanted, on the dirty wall. Once again, anything actively religious is confined to the past. Notably, one of the most well-known

Jewish photographers, Mikhail Greim (1828–1911), resided in Kamenets-Podol'skii and produced a whole series of photographs of 'Jewish types'. It would hardly be surprising if the photo in the Magazanik house was shot by him; perhaps Ginzburg found it on one of his 'ethnographic expeditions'. Greim's photographs of the Old Town in Kamenets invoke the city atmosphere, similar to the one on-screen. The camera switches to Vavilova, sitting on the bed as if mummified, with her shadow – her mythological self – reflected on the wall. Maria enters and begins a conversation. She observes Vavilova with a slightly ironic smile, and asks whether she is right in thinking that 'Madame Vavilova' is pregnant. Vavilova explains, much to Maria's horror, how she tried to kill the foetus by drinking iodine, but to no avail. In the script, when Vavilova wakes up, she begins to sweep her room while recalling her childhood in the village of Kanaevka. Her embrace of the Revolution was caused by the poverty and hardships she experienced. She remembers her mother's funeral with pain. Vavilova's pre-history firmly places her in the realm of life with its natural cycles, validating her role as a mother. On-screen, however, her peaceful chatting with Maria, who begins to educate her in all things feminine, comes out of nowhere.

In a monologue taken almost verbatim from Grossman's story, Maria describes her children as both her blessings and curses to the commissar, who is drinking tea with large lumps of sugar. Maria seems amused that not one of them has yet died. Her attitude toward rearing children and the pain associated with it recalls, unsurprisingly for Grossman, the conversation of Dolly Oblonskii, also the mother of many children, with Anna in Leo Tolstoi's *Anna Karenina* (1873–77). Maria offers Vavilova Efim's slippers, saying that a pregnant woman cannot be barefoot. Whether Askol'dov was aware of the custom or not, being barefoot in Jewish households is a bad omen, since mourners are required to be without shoes when observing the seven days of mourning [*shivah*]. Maria hereby wards off death from the house and the future mother. Under protest, Vavilova places her large, swollen feet into the half-torn slippers and whispers to Maria when she is due. There is an idea of *vzhivanie* – the Russian term for literally entering someone else's life – present here. With their world spread out in front her, Vavilova becomes part and parcel of the Jewish household, and begins to understand their language. It is crucial, however, that her world of Revolutionary brutality and visions remains hidden from them, and can be reactivated within her at any moment.

As the camera pans over the desolate foggy town, with the diegetic mournful church bells ringing, a visibly drunken Efim is marching back home. Humming to himself the same Jewish-sounding melody he droned in the morning – a Hebrew chant of sorts [*niggun*] –he is now offering his pantheistic prayer to the night that is filled with pastoral cricket sounds. The dogs bark and a few Red Army horsemen, holding torches, swiftly pass by him. He is

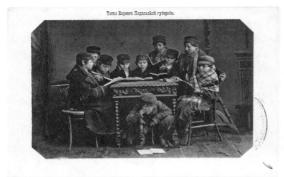

Figure 9: Mikhail Greim, 'Jewish Types of the Podol'e Governorate'.

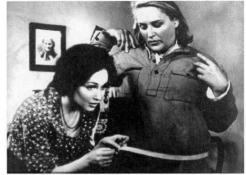

Figure 10: Efim and Maria make a dress for Vavilova. Still from the film.

frightened, with his face cringing in terror, and huddles against a brick wall. Quickly realizing that the threat has passed, he begins to laugh to himself and, slightly hunched, moves on. Efim turns into the prototypical figure of the Jew as a victim, reminiscent of certain Jewish types in Babel''s *The Red Cavalry* and the Jew killed by a Ukrainian horseman in Bulgakov's *White Guard*. He is also a prototypical Yiddish *schlemiel*, who, perhaps delusional, keeps on moving despite the world's intent to destroy him. The episode parallels the earlier washing scene, but with a striking difference: Maria stands tall against the *tachanka*, while Efim is consumed by fear, making him weak and, in stereotypical terms, feminine.

At home, Maria and the commissar are sitting at the table, with the hanging lamp peacefully throwing light on their faces. Maria continues to educate Vavilova about the hardships of bringing up children, incomparable, she says, with the simplicity and 'pif-paf' of the war. Vavilova is surprised and frightened. Like a mouse, Efim tiptoes into the house, overhearing their conversation. Slightly annoyed, Maria beckons him to come in. She gleefully informs him that 'Madame Vavilova' is expecting a child. Chewing his food, Efim is gloomily silent. Finally, he sardonically intones, 'What am I supposed to do? The Red Cavalry has found the time and the place to give birth'.[19] Here Efim, the cowardly *schlemiel*, turns into a sarcastic wise guy.

The next morning begins with Maria tearing fabric to make a dress for Vavilova. As is the case with the slippers, tearing invokes mourning, as Jews are required to tear a piece of their clothing to mark the passing of a loved one. Thus, premonitions of death are found in every activity in the Jewish household, even those connected with ushering in a new life. As Maria measures Vavilova's vast thighs and waist by cladding her in newspapers, Efim is working on a sewing machine, admirably commenting on Vavilova's physique. Maria, whose attitude toward her husband is always half-contemptuous, calls him by the neologism 'nincompoop' [*laptsedron*] – Askol'dov's attempt at sounding Yiddish. Significantly for the later crucial scene in the cellar, he proclaims that one day 'trams will be running in our town' and he will be getting to work by one. Everyone laughs. As in Greek tragedy, these characters, situated fully in the here and now, are blind to what awaits them. To access the future, they will need to reactivate the symbolic register. According to Joe Andrew (2007: 33), Vavilova 'becomes part of the matriarchal Eden'. Yet the Magazanik household is hardly a paradise, filled as it is with diseases, fears, the constant berating of the husband and death omens. It does represent, however, Askol'dov's full-blown attempt at mimetically replicating a family life, with all of its joys and sorrows, and what he – relying on Grossman and Chekhov, literary types and stereotypes, and his own vision of the 'savage' Jew – thought Jewish life was like.

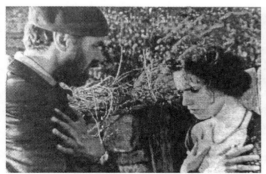

Figure 11: Askol'dov and Nedashkovskaia on the set. Image provided by David Roizen.

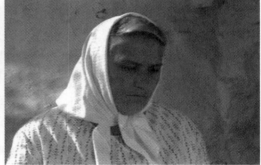

Figure 12: Vavilova, the future mother. Still from the film.

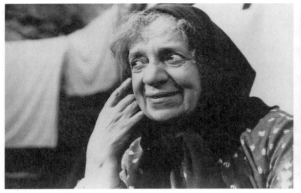

Figure 13: Grandmother
Magazanik (Liudmila
Volynskaia). Still from the
film.

Figure 14: Efim and Maria
assist Vavilova in labour.
Still from the film.

Sitting with Maria, the children and the senile grandmother in a sun-drenched yard, Vavilova is wearing her new dress and a traditional white Russian kerchief on her head. She has undergone a thorough transformation. The most arresting element in this idyllic setting is the older, dark-haired, beautiful daughter Sonia, who, while holding her baby sister, looks forebodingly into the camera. Sonia ideally fits the type Askol'dov sought. In the local newspaper, on the eve of the film's shooting, there was an advertisement calling for 'dark-haired children' – a euphemism for Jews – to come for screen tests. The girl playing Sonia, however, came from Odessa. The wife's berating and Efim's humming continue. Back to his role as a *schlemiel* and reminiscent of Menachem Mendl, played by Solomon Mikhoels in *Jewish Luck*, he dreams of resting on a beach in Odessa. He is a paradigmatic *Luftmensch*. Though seemingly part of this new life, the baffled Vavilova continues to observe it as a deeply alien space that operates according to some strange rules. She smiles at Maria, who is washing her toddler's bottom with one hand and his face with another (the rules of hygiene are not strict in this 'Eden'). Efim brings out an old iron bed for the baby from the basement, and Maria sends Vavilova back into the house to rest. What none of them realize is that the life growing inside her will have a meaning far outside the confines of their *byt*.

BIRTH

Vavilova is the only female commissar in Soviet literature and film who gives birth. Consisting of elaborate montage sequences – Vavilova's labour intercut with three apocalyptic visions – the birth scene cuts the flow of mimetic reality and reactivates the film's symbolic terrain. Unprecedented in its mythological intensity and density, and fully an invention of Askol'dov, it sits in its own category in the context of contemporaneous Soviet film, despite its affinity with the poetic cinema of the 1960s, and being a throwback visually to the art of Sergei Eisenstein, Vsevolod Pudovkin, Aleksandr Dovzhenko and, more broadly, D.W. Griffith's deeply mythological *Intolerance* (1916). In the inspiring words of Maria Deppermann (1997: 578) 'Askol'dov's huge accomplishment in these sequences will go down in cinematic history. Through the montage of images, Askol'dov penetrates into a spiritual dimension, one worthy, indeed of Ejzenstejn's vision of the "cinema of ideas"'. Thus, considering the centrality and complexity of these episodes, I will first offer their detailed description, and then analyse their rich network of meanings: cinematic, scriptural, literary and visual.

The scene begins with Vavilova lying on the table and sporadically screaming, her face in agony. Because we only see her face and part of her torso, she seems to be cut in half. Addressing her with the familiar 'thou' – no longer

 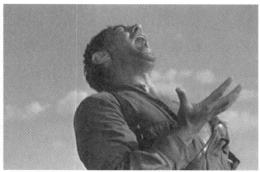

Figure 15: Vavilova's
second vision. Still from
the film.

Figure 16: Vavilova's third
vision: death of the beloved.
Still from the film.

the reverent 'Madame Vavilova' – Maria slaps her on the cheeks and commands her to weather the pain. Efim and the children are busy clearing away everything from the room, as they did earlier when Vavilova moved in. The deaf grandmother, who here resembles a witch, stands over pots of boiling water. Evicted by Maria, Efim leaves the room and this time kisses the *mezuzah*, presumably to ensure God's protection over Vavilova. Maria covers Vavilova with a white sheet, which, in Judaic terms, signifies death: a dead body is covered in white shrouds [*takhrikhim*]. Yelling 'I cannot breathe' ['*Mne dushno*'], Vavilova experiences the first vision.

In a desert, scorched and crackling under the sun, there are four Red Army soldiers. One of them, with his eyes bandaged, yells 'Help', while another kneels in a praying position and holds onto his rifle. The third soldier stands frozen, staring at the sand, and the fourth, also frozen, looks ahead while clenching the rifle for support. The rest of the soldiers are dragging a *tachanka* with horses through the dunes. The soundtrack, as in the preamble, is jittery, consisting of single notes. Vavilova, in a military garb, appears and helps to push the *tachanka*, but to no avail. There is Eisensteinian montage here of metonymic fragments: horses' feet; the soldier's sweaty backs and faces. The horses are whipped mercilessly and finally the *tachanka* begins to move. Vavilova's heavy breathing is heard and, shot from a high angle, evoking Dziga Vertov's rotating street in *Kinoglaz/Kino-Eye* (1924), the soldiers perceptually turn upside down before beginning to run. The lonely blind soldier yells 'Help!' again. They eventually reach water and, resembling horses, drink from the waves. The camera again hurls itself upside down and, straightened up, cuts back to Vavilova's lips, thirstily imbibing from the cup.

We are back in the Magazanik house. The contractions end and quickly resume, leading to the second vision. Back in the desert, amidst the white sands, blown by the wind, two figures are glimpsed in the distance, clad in leather army jackets. One of them is Vavilova and another a bespectacled man (Otar Koberidze). They stand next to a *tachanka*, whose phallic barrel Vavilova begins to caress. The man hungrily kisses Vavilova while the non-diegetic church bells are heard. In the distance, in a slanted shot, nine soldiers appear with scythes in their hands, who then swiftly mow the sand. They come closer and the vision ends.

Maria is slapping Vavilova, trying to revive her. The rain is pouring outside, and Vavilova dolefully implores: 'Do not torture me'. 'God, help us', the Jewish woman says in Yiddish and turns on the lamp. Almost an entire day has passed. Maria curses the not-yet-born baby's father and bemoans the fate of women. Outside, working with his tinplate, Efim covers his face as if crying. Nature and the house are suffused with the apocalyptic anticipation, and it seems almost certain that Vavilova will die. She herself yells out, 'I will not survive', and, with the lamp violently swinging above her, falls into the third and last vision.

Red Army soldiers are galloping through tall grass. One rider, swinging a sword, is pursued. As he jumps onto the bridge, a bullet pierces him. His horse rears up and loudly neighs, while his glasses, in an allusion to *Battleship Potemkin*, fall to the ground. He emits a horrible silent cry while Schnittke's dramatic leitmotif is heard, then bares his chest and falls on his back (all in slow motion), his head and one arm hanging over the bridge's side. Though his face cannot be seen, the glasses suggest that he is Vavilova's lover from the previous vision. The camera rapidly pans over the landscape as if moving forward in time. Horses without riders are galloping over the bridge and through the valley. As they rush through, Schnittke's unnerving score mixes with the voices of the dead riders. Now a woman's scream echoes in the air, mingling with the firing machine gun. Through the dust, we discern that the horses are passing through a makeshift cemetery, with crosses rising above ground. The stallions reach water and drink peacefully. The vision ends.

Maria, with her hair dishevelled, walks into the rainy courtyard and announces to Efim and the children: 'We have a boy'. Efim takes off his hat, which, according to a Russian custom, one does when receiving news of death, and begins to cry. He says, 'I swear to God I knew it'd be a boy'.

The birth sequence perfectly and masterfully showcases the two-dimensional structure of *The Commissar*. A comparison with Roman Polanski's *Rosemary's Baby* (1968), released in the United States as *The Commissar* was put on trial, illuminates this polarity. As the drugged Rosemary, copulating with her husband, is being impregnated by the Devil in a series of phantasmagorical visions on a ship, Vavilova, experiencing an excruciating labour, is in fact participating in her 'Red religion's' apocalyptic scenario. 'This is not a dream, it's real', Rosemary screams in horror, and so can Vavilova. Unlike in the script, where her visions are actual memories of a battle and the heroic death of her beloved depicted in typical socialist-realist terms, here they are part of a mystical reality which only Vavilova can access. On a human level, the bond between her and the Magazaniks grows stronger; on a symbolic level, she is wholly removed from them while they become the sole facilitators of an apocalyptic drama. Unlike in Grossman's story and the script, no midwife assists during her labour. The symbolic embeds itself into the mundane through physical manifestations, such as Vavilova's thirst or the pushing of the baby/*tachanka*, which makes the correspondence between the two layers visually seamless and the symbolic texture tangible. What counts, however, is the invisible, since the film's main motifs – horses, *tachanka* – represent here the fulfilment of their apocalyptic potential. Askol'dov's apocalypticism is eclectic and idiosyncratic, and does not follow any strict doctrinal or scriptural outline. As befits any apocalyptic plotline, however, what appears as negative and destructive in it is in fact positive and redeeming.

The apocalyptic reversal begins with the desert, a symbolic and mythologically ambiguous space. In biblical terms, it is the setting of the covenantal promise to Abraham and Jesus' temptation by the Devil. In the cinematic ones, it invokes the degradation of civilization (e.g. Antonioni) and the hardship of the Civil War. Grigorii Chukhrai's *The Forty-First* takes place in a Central Asian desert, where the stranded soldiers are dying one by one until the survivors reach the sea. *The Commissar*'s desert visions were shot in a steppe, in the southern Kherson region of Ukraine. Ginzburg remembers that his aim was to create an illusory, deformed atmosphere. His upside-down shots signal the apocalyptic topsy-turvies. Bright sunlight envelops the scenes and seems supernatural, especially in contrast with the gloominess of the town.

Most significantly, the visual elements appear as citations from scripture. The main source is Matthew 24:8, where Jesus announces to the disciples the future destruction of the Temple: 'But all these things are merely the beginning of birth pangs' (New American Standard Bible 1971). A central concept in both Jewish and Christian eschatology, the birth pangs refer to the devastation preceding the redemption and coming of the Messiah. This is precisely how Vavilova's actual birth pains demand to be interpreted: as the language of Revolutionary eschatology, where her son, the moment of whose actual birth we crucially do not see, is the Red Messiah. The omens of death, interspersed throughout the scene, thus all lead to life. While in the physical, historical world sowing anything in the desert is impossible, in the confused apocalyptic setting it is a generative act. Similarly, though the pain of the blind soldier yelling for help is visceral, blindness here, in line with the Gospel logic, bespeaks insight.[20]

As in the previous scenes, Askol'dov aestheticizes and eroticizes violence. The *tachanka* – the antithesis of the Jewish body – is an extension of Vavilova and her beloved's sexuality, as well as of the symbolic conceiving of their messianic offspring. His bloodless demise resembles that of Emelin, which intensifies the sacrificial element of both deaths. Played by a star of Georgian cinema, the child's father appears exotic, overtly masculine and otherworldly. While in the Russian/Soviet context glasses often connote intellectualism and Jewishness, here they are part of his ruggedness and epic stature. His end, necessary for the birth of the son, is nothing short of the beautiful death of a Homeric warrior, sharply different from his sorrowful perishing as mourned by Vavilova in Grossman's story.

Ultimately, the horses act as the unifying link in this apocalyptic jumble. As David Bethea has pointed out in his commentary on the centrality of the steed in Russian apocalyptic literature:

[…] the horse is a powerful visual tool […] precisely because it is capable of telescoping in one economical image several traditions (the imperial, the folkloric, the religious) and because its inherent qualities (speed, beauty, elemental forces, comradeship, martial powers) make it an ideal symbol for eschatological transit, for the tumultuous 'ride' from one space-time to another.

(Bethea 1989: 47)

The horses' leap forwards at the end of the third vision represents precisely this 'tumultuous ride'. The horses are central to the film's metatexts – Babel''s *The Red Cavalry*, Bulgakov's *White Guard* and *The Master and Margarita* – and are a conspicuous presence in Soviet visual and cinematic depictions of the Revolution, which originate in Kuz'ma Petrov-Vodkin's 'Kupanie krasnogo konia'/'Bathing of a Red Horse' (1912).

As Andrei Platonov had in *Chevengur* (1928), Askol'dov radically makes horses the absolute embodiment of the Revolution at the expense of human beings[21] Askol'dov separates the horse from the rider, or rather frees the horse from the punishing presence of humans and human-made machines (i.e. the *tachanka*). The first vision begins not with the four horsemen of the apocalypse, but with four solitary horseless soldiers. When the soldiers finally reach water, they behave like horses and find redemption in this animalistic behaviour. The third vision ends with the horses peacefully drinking water – they are the new Revolutionary reality – while the actual soldiers are all dead, sacrificially left behind. In the words of Evgenii Margolit, the result of Vavilova's visions is 'the one replacing thousands. The newborn one. And on a higher symbolic level, the one and the thousands equal each other' (Margolit 2012: 536). This new being emerges out of the final horse utopia.

Consistent with the rest of the film, the actual enemy – the Whites – remains unseen. Similar to the Kabbalistic myth of creation, the Revolutionary apocalyptic saga unfolds internally, which again indicates that Askol'dov is thinking not on the historical, but on the symbolic level. Not unlike in his favourite *The Master and Margarita*, 'the tenacious presence of the imagery cannot be accounted for merely in terms of realistic motivation' (Bethea 1989: 209). The horses in the visions are the compensation for the pile of horseshoes in the earlier scene in the square. The young soldier's shot into the air at the start of the film should thus be seen as the announcement of the future apocalyptic self-actualization. Thus, Askol'dov creates 'symmetrical patterns across large spaces of time' (Tsivian 2008: 71), which carry the film's ideological weight.

According to Andrew Barratt, Vavilova's delirium represents a polemical response to Eisenstein, with quotes from *Ivan the Terrible* and *Battleship Potemkin*. He argues that Askol'dov reverses Eisenstein's optimistic reading of the Revolution, and instead depicts 'the revolutionary impulse of Bolshevism as a force which opened a fatal gulf between utopian dream and the brute experience of history' (Barratt 2001: 159). Our apocalyptic reading of the birth scene suggests, however, that Askol'dov makes the 'brute experience of history' irrelevant to the 'utopian dream' by insisting on the brutality and destructiveness necessary for the realization of the Revolutionary promise, while conversely allocating its violence to a symbolic corner where it becomes theatrical and self-referential. In the absence of the actual traditional deity, the audience should wonder what this apocalyptic mythology viably signifies, apart from it being a hypnotic visual spectacle. The film's censors identified the birth visions as 'unreadable' or 'uninterpretable'

[*neprochityvaemye*] (Troianovskii and Fomin 1998: 278), which meant that they could not by any stretch of the imagination fit the officially prescribed historiography of the Revolution. Paradoxically, however, it is through them that Askol'dov also offered a drastic alternative to the idea of 'socialism with a human face'.

Not surprisingly, the beginning of the next scene reinforces the messianic nature of the newborn. The camera captures again the domes of the Church of the Protection of the Mother of God, whose bells are ringing. Thus, the messianic promise has been fulfilled. The apocalyptic mixture of life and death is present here as well, because the bells can also be rung to announce a death in town. The trope of reconciling the traditional religious and Revolutionary mythologies, which will be central to the upcoming scene, is set into motion. The camera abruptly cuts to a bustling market, built for the set behind the Dominican cathedral. It is filled with people, who are loudly bargaining and dancing. Among them are women dressed in traditional Ukrainian garments. A street musician, played by an actual local Jewish wedding violinist and the father of many children (V. Mitsman), strikes a Jewish-sounding melody on his fiddle. There is a market episode in both Grossman's story and the script, where it is an organic part of the animated daily town life. On-screen, it falls completely outside the film's portrayal of the city as a place of emptiness and ruin. Perhaps the desolation is broken as a result of the baby's birth; the rest of the film, however, does not support this reading. Both Vavilova and the Magazaniks are conspicuously absent at the market – Vavilova with the baby is there in the script – which signals that they continue to reside within their solipsistic mimetic and symbolic realms. Noticeably, there is also an old Jew selling a horse to some brute who cruelly examines the mare, which sharply contrasts with the free horses in Vavilova's last vision. The superfluous market episode leads into the supremely important procession scene – completely absent in the script – which establishes the symbolic parameters of Jewishness.

PROCESSION/SYNAGOGUE

Soft church bells are ringing in the film's diegesis. A group of men – some dressed in work uniform, others half nude – are fixing cobblestones on a street pavement with their hammers. The sounds of bells mingle with the strikes of the hammers. One of the men, with his forehead bandaged, looks up and reverently gazes at something. A couple of others do the same. Vavilova, holding her swaddled infant, gracefully passes by and smiles at them; we realize that they are looking at her. Her head is covered by a kerchief; she is clad in a simple dark dress. The camera closes in on her no-longer-swollen feet in simple but elegant shoes. The non-diegetic majestic melodious sounds of Schnittke's 'Symphony No. 4' are playing on the soundtrack. This is the first time that we see Vavilova in her role as a mother. The image of the mother is prominent in both avant-garde early Soviet art (e.g. Petrov-Vodkin's 'Petrogradskaia madonna'/'The Petrograd Madonna' [1918]) and the later socialist-realist literature and cinema, the basis for which was Maxim Gor'kii's novel *Mat'*/*The Mother* (1906), famously adopted by Vsevolod Pudovkin for the screen in 1926. Vavilova's character hearkens back to these sources, but ultimately is emblematic of Askol'dov's idiosyncratic mythology of the Revolution.

The choice of the cobblestone workers who are transformed by the vision of Vavilova is not accidental. The most prominent socialist-realist sculpture is 'Bulyzhnik – oruzhie proletariata'/'A Cobblestone is the Weapon of the Proletariat' (1927/1947) by Ivan Shadr. A symbol of the heroic Revolutionary era, it depicts a squatting half-nude worker holding on to a cobblestone as a disk, ready to hurl it. The cobblestone scene should be seen as a quote of the sculpture; the resemblance between it and the foregrounded half-nude worker on-screen is striking. Thus, the scene is deeply mythological. Vavilova is a 'Bolshevik Madonna' (Berghahn 2006: 183) who appears to the proletariat as a deity, not unlike the figure of Jesus in Aleksandr Ivanov's painting, 'Iavlenie Khrista narodu'/'Christ's Appearance to the People' (1837–57). The workers are paving the street for her.

As Vavilova continues on the winding cobbled path, behind her, in the distance, the familiar Russian Orthodox Church of the Protection of the Mother of God (Pokrovskaia), with both a round and a pointy dome, is visible;

meanwhile, the soundtrack acquires a liturgical dimension. Located in the Russian Estates neighbourhood of Kamenets-Podol'skii, this church, built in the nineteenth century, was the only functioning one in the city throughout the Soviet period. With the camera first tracking the mossy rock wall, it switches to Vavilova walking beside it. Her gaze is apprehensive; she is clearly looking for something. She comes upon a Catholic priest, played by the film's assistant director, V. Grigor'ev, whom she greets with a slight bowing of the head. Inaudibly to the viewer, he says something and points her in the direction of what she is seeking, and, as she disappears, reverently takes off his hat and gazes after her. He is also transformed by this vision of the Madonna. Vavilova is now walking through an empty church courtyard, with its lonely statues of saints, as an organ component is added to the soundtrack. This is what she needed to find. The church is the beautiful Trinitarian Catholic cathedral built in the eighteenth century. The next and most significant and symbolic stop on her path will be a synagogue.

As Elena Stishova has perceptively argued:

> For the commissar, revolution and religion are the same. She earnestly confesses her revolutionary faith. She christens her son at the font of the Civil War […]. Clavdia proudly carried her infant through the town square, where the Orthodox cathedral, the Catholic church and the synagogue all meet – a symbolic passage of the Bolshevik Madonna past the places of worship of all alien faiths.
>
> (Stishova 1993: 183)

The key here is 'all alien faiths', and thus Vavilova's walk is not a 'metaphorical baptism' (Monastireva-Ansdell 2006: 245). The shot into the air in the square with the adjoining church and the synagogue at the beginning of the film is again clarified by this chain of motifs. The film reconciles the Revolutionary religion with the old monotheistic creeds by establishing the Revolution's primacy and grace toward them, which is certainly different from the violent Soviet delegitimizing of religion. While Vavilova's religion derives from the new reality and ethics of her visions, the three 'alien faiths' reside amidst an atmosphere of emptiness and destruction, where symbolic Jewishness occupies a central place.

Vavilova walks into a large, imposing, ruined structure covered in scaffolding. The camera closes in on her, with the baby in her arms, standing in a sizable empty arch window. This is Askol'dov's icon of a Bolshevik Madonna. Arches, as we recall, were also prominent at the film's beginning: the square was seen through an

Figure 17: Ivan Shadr, 'A Cobblestone is the Weapon of the Proletariat'.

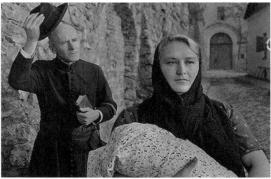

Figure 18: Vavilova's procession to the synagogue. Still from the film.

arch; Emelin passed under an arch as he was chased to his death. In a panoramic circular shot, the camera pans around the inside of the structure. The arches – broken windows – are all around, with large Jewish six-pointed stars visible in between them on the crumbling walls. They indicate that this is a demolished synagogue. A lonely figure, skilfully played by the cinematographer Valerii Ginzburg, clad in black clothes and with his head covered, stands in one of the arches facing outward. He is almost imperceptibly swaying, in a stereotypical Jewish prayer fashion. As he turns around, we see that he has a long bushy beard, not unlike that of the grandfather in the portrait in Magazanik's house. With a stern facial expression, he slightly bows his head toward Vavilova, a gesture she somewhat haughtily greets with a coquettish smile. The soundtrack acquires a traditional minor key Jewish tonality, all part of Schnittke's symphony of three religions. She turns around, descends from the arch and is seen walking down an unpaved grassy road, with a synagogue appearing small in the distance and its blind empty arches glaring.

The synagogue scene is sublime and a cinematic masterpiece. It is obvious that the relationship between the Red Madonna and the rabbi is different from her encounter with the priest. The rabbi is not overpowered by her; he proudly holds his ground. His synagogue may be destroyed but it is not internally defeated. Vavilova is embedded into the synagogue stone frame, yet she keeps her distance from the rabbi. There is an understanding and an almost erotic interplay between them. The synagogue, which dominates the film's symbolic terrain, holds the key to Askol'dov's mythological poetics of Jewishness. *The Commissar* portrays two apocalyptic models: that of the town's desolation and perpetual mesmerizing wreckage, where Jewishness is the centrepiece (the synagogue in the preamble is not destroyed but also decrepit and empty); and that of the Revolution's violence, sacrifice and messianic redemption. In the first model, time is motionless, and in the second, it contracts (birth) and jolts forward (horses). The film's ultimate questions are: how do these two models interact and relate to the mimetic reality of Magazaniks, where time does not stand still? To arrive at his poetics of Jewishness, Askol'dov sidesteps historical reality and Jewish memory tropes, and creates a mythological time filled with diegetically meaningful but historically inopportune relics.

Why is the synagogue in ruins and scaffolding? The Big Artisans' Synagogue (Gros Snayders Shul, or Remisnycha Synagoga), also known as the Tailors' synagogue, was built in the second half of the nineteenth century (its first mention dates from 1872) on a plot where an older synagogue probably used to stand. Overlooking the Smotrich' River, the imposing, architecturally eclectic three-storey building was adjacent to the sixteenth-century Potter Tower, and was representative of the so-called fortified synagogues of the Podol'e region. Having first settled in Kamenets in the sixteenth century, by 1892 Jews constituted roughly 40 per cent of the city's diverse population, though it was

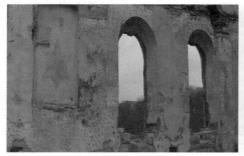

Figure 19: Inside the ruined synagogue. Still from the film.

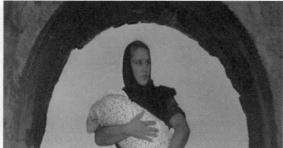

Figure 20: Vavilova in the synagogue arch. Still from the film.

never defined as a *shtetl*. The Big Artisans' Synagogue, located on Jewish Vali Street, was the centre of its vibrant religious life, which boasted two other synagogues, 21 houses of prayer and two religious schools, housed in the Big Artisans' Synagogue itself. The synagogue continued to function all through the Civil War period, but was officially shut down in 1936 at the height of Stalinism. In 1941, the synagogue was destroyed during a Nazi air raid. In 1959, the city decided to reconstruct it and turn it into a restaurant, which opened in 1968 and operates to this day.[22] Interestingly, the restaurant interior was decorated by a local graphic artist, Semen Rosenstein (1926–2006), who emigrated to Israel in 1970, where he became well known for his paintings depicting synagogues and Jewish religious life. The scaffolding seen in the film is part of this sacrilegious reconstruction.

The Jewish history of Kamenets was completely omitted from Soviet historical guides to the city, and so it is entirely possible that Askol'dov knew nothing of it. Remarkably, after the film's release in 1987, he began to fashion his own history, which, as I have argued, transplants the anti-Jewish violence of the Civil War period depicted by Babel' onto the Soviet reality of the 1960s. According to Askol'dov, on the eve of his and the crew's arrival in Kamenets, a wave of small pogroms swept through Ukraine: the synagogue in Kamenets was set on fire and it is this burnt structure that is included in the film. He says that in the nearby town of Khotin, he was led to an underground synagogue where the rabbi told him that no Jews would participate in his film as extras because of their anger at the regime (Rokhlenko 2007).

The overall impression coming from these 'recollections' is that Askol'dov was dealing with an organized and deeply pious Jewish community. By 1966, though the Pale of Settlement was fully gone, Soviet Jews retained numerous, often complex traces of Jewish memory. However, they constituted no autonomous community and were by no means a homogeneous group. Frequently subject to quotas and various degrees of discrimination, they were fully integrated into the overall society, and had to abide by its rules, often shaping these very rules from their professional and intellectual positions. While in the capitals and larger cities some synagogues stayed open, they were practically all closed down in the former Pale in the late 1930s or shortly after the war. The Khotin synagogue mentioned by Askol'dov was closed down in 1961. Despite the severity of measures in the 1960s against the few remaining observant Jews, who would gather in private apartments for makeshift services, there were no pogroms in Ukraine, notwithstanding a few sporadic acts of vandalism. The Big Artisans' Synagogue, ruined and non-functioning, was not and could not have been burned after the war. During the Civil War, despite pogroms, destruction and unrest, it stood as a house of worship and study, with prayer quorums and the Torah arc. Thus, Askol'dov's thinking is twofold: while he personally imagines Jewish history to be impervious to change and always

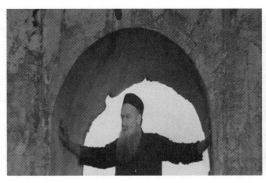

Figure 21: The rabbi
(Valerii Ginzburg). Still
from the film.

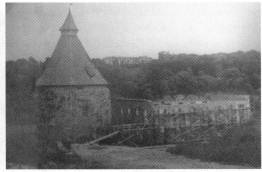

Figure 22: Tailors' synagogue
after the war. Image courtesy
of Anna Kupinska.

mired in oppression, his cinematic mythology paints Jewishness as eternal apocalyptic rubble; an uncanny place that both repels and attracts.[23]

As Vavilova leaves the symbolic area of temples, she crosses over into the mimetic realm. Walking down a steep cliff away from the synagogue, she chances upon a group of Red Army soldiers. We first hear their horses' neighing, which interrupts the chirping of birds in the sunny air. The handheld camera briskly freezes on Vavilova's face. It is stern and unforgiving, evocative of Maria's expression in the *tachanka* episode. From a transfiguring Madonna she turns into a warrior Amazon, ready to protect her child. The moment is fleeting though. The soldiers recognize Vavilova and mock the commissar by calling her 'citizen [*grazhdanochka*] Vavilova'. She runs away from them, clearly frightened. Non-diegetic rifle shots are heard while horses, the sign of the Revolutionary future, are peacefully chewing grass nearby; they take no interest in this hounded earthly woman. Vavilova runs across a shaky suspension bridge; we do not see her – it is a subjective camera shot – but only hear her heavy breathing. She runs into a cliff rock wall and, as the camera hypnotically pans over it, collapses on the ground, sobbing uncontrollably.

This crossing of the bridge references the horses galloping on a swaying bridge in the birth visions. While they reach the apocalyptic redemption, she crosses over into a zone of womanhood (assaulted by men) and the zone of Jewishness (assaulted by the outside military world). Vavilova transforms into a double of Efim, who was terrified of the Red Army horsemen in an earlier episode. With this replication of Jewish behaviour, the apocalyptic Revolutionary project is suspended (but not cancelled), as Vavilova sees a beautiful foal washing in the river in the glistening sunlight. It is unclear whether it is real or a phantom, but it is the embodiment of the Revolutionary ideal. Schnittke's majestic symphony resumes and, in a wide shot, a composed Vavilova walks back to the Magazaniks along the cliffs of the Smotrich' canyon.

The next day, Vavilova is visited by her regiment's commander who sent her to the Magazaniks, accompanied by the officer who had arrested Emelin. She behaves as a mistress of the house. Having just washed the floors, she orders the men to wipe their feet. Acting as if surprised that he actually exists, they observe the boy serenely sleeping in the crib, which Vavilova begins to rock. They inform her that the Whites are advancing throughout Ukraine, forcing the Reds to retreat. As a result, they will be leaving her behind unless she decides to travel with the troops in the field hospital. Her attitude toward her comrades is derisive; she is bothered by their cigarette smoke and inopportune jokes. The three Magazanik children are looking into the room through a window and the officer pretends to shoot at them with his fingers. The children laugh, but Vavilova is not amused. She notices the officer's gold watch, probably stolen; his dedication to Revolutionary ethics is suspect. The two men leave, telling her that she can now 'breathe'. She is proudly silent and does not say goodbye.

Efim and Maria step into the room; they have heard everything. They tell 'Madame Commissar' that she can stay with them; the sugar and flour she will be getting from the army will be enough to feed everyone in the house. Vavilova admonishes them that, should the Whites find out about her living here, the whole family would be shot. 'You have children', she intones. 'We have children, you have children', is Efim's response. He implores Maria not to try to scare him. 'I've been told to be scared of everything since the day I was born', he explains, agitated. Shaking his finger at Maria, he declares: 'The case's closed'. The weak, frightened Jew becomes a deeply decent human being, and a hero who makes correct ideological and moral choices. With hindsight – and perhaps this is what Askol'dov was after – it is hard not to see this scene, absent in the script, through the lens of righteous gentiles who hid Jews during World War II.

LULLABIES

In the next room, the grandmother is praying out loud in Yiddish by a lonely candle, asking for God's protection from the murderers in this time of trouble. Again, we are in the realm of eternal Jewish persecution. Originally, her lips were inaudibly moving; Yiddish without subtitles in Russian, and thus incomprehensible to the audience, was added when the film was reconstructed in 1987. The grandmother is played by Liudmila Volynskaia, a Russian actress

who did not know Yiddish. Extraordinary in its Jewish bluntness for Soviet cinema, the scene's lyrical dramatism, however, smacks of a cliché, especially considering the ineffectiveness of religion as a living daily presence in the film and the antiquated status of Yiddish in the Magazanik household.

The supplication ends while the diegetic Russian lullaby commences, the same that started the film. Vavilova, pacing with the child in her room, lit by a lonely candle, is singing softly. On the one hand, she echoes the grandmother's prayer but, on the other, her dark shadow on the wall reminds the viewer of the symbolic part of her being, now inactive. As the lullaby continues, the camera pans over the sleeping Magazanik children and the room with its Jewish paraphernalia: a candle, the portrait of the grandfather, an old book. Shot at a studio in Moscow, the still of this scene was included in the *Sovetskii ekran* article (Kim 1967). Awake, Maria tells Efim that this *katsapka* behaves like a true Jewish mother, going crazy worrying about her child. Efim is not surprised: a woman, even in military pants, still remains a woman. He pours water into a basin and, like Christ in the Gospel of John washing the apostles' feet, proceeds to bathe Maria's feet in it. On his knees, looking at her in admiration, he says: 'Maria, I love you'. Clasping his head and lowering it suggestively and erotically downward, Maria whispers that she is afraid. As the camera swings back across the room like a pendulum – over the portrait, the candle, the old book and the children – to return to Vavilova, a Jewish lullaby without words, probably hummed by Maria, is introduced. Ultimately, the two cradle-songs blend. The entire shot seems to rock like a cradle to their tunes.

The scene is beautifully composed – according to Askol'dov, his favourite part of the film was Efim telling Maria that he loves her (personal communication April 2015) – but it is also overtly sentimental and, as was rightly noticed by Trauberg in his last letter to the studio, too long ('unending') (Troianovskii and Fomin 1998: 278). Most importantly, the union between the Jewish and the Russian halves enacted through the fusion of melodies seems forced and does not entirely succeed. As Margolit (2012: 537) insightfully claims: 'The two worlds observe each other compassionately, even benevolently, but consistently maintain the demarcation line between each other'. The scene is almost the exact replica of Vavilova's first night in the house. Although she is now much more attuned to its cries and whispers, and shares in the family's fate, the 'demarcation line' remains because the house is a platonic cave, a mere shadow of the divergent Jewish and Red/Russian symbolic realities.

The nocturnal tranquillity is illusory. The next day, with their horses and *tachanka* carriages sinking in mud, the Red Army is fleeing the town. They pass through the same square, marked by its synagogue, that they occupied at the beginning. As always, everything around is completely desolate. The scene is remarkably different from the script, where local women run after the Bolsheviks, bidding them farewell and giving them food. On-screen, two filthy cows, whipped by a soldier, are dragging a rusty fortified truck through the street. The image is eerie and grotesque, and signals the ugliness and meaninglessness of the war and the powerlessness of the Reds. 'Will they return triumphant?' is the question the film will have to answer.

The next scene, also absent in the script, is a reversal – a crooked mimetic mirror – of Vavilova's visitation of the temples. The camera stops at the same Orthodox church, the Dominican cathedral and the synagogue – not the symbolic ruined one, but the intact one on the square. In each case, the shot begins below, with a solitary figure boarding up the doors, and then, redolent of their earlier angled presentation, rises to the top of the temples. Within the cataclysmic atmosphere, these religious structures are permanently skewed, and the relationship between the lower and the higher spheres irreparably broken. We see a few other people boarding up their high windows. The camera panoramically circles around the square, its buildings all nailed down, while the non-diegetic sound of the marching boots, presumably of the Whites, resounds. Just like at the beginning, a white flag of surrender is hanging from the town hall's window across from the synagogue.

Again, Askol'dov's historical and symbolic registers intermingle. On the one hand, the scene conveys very clearly his view of the Civil War as a tragedy in which there are no winners and everyone is defeated. It does not matter who occupies the town – the Reds or the Whites – the consequences are equally devastating for its inhabitants in either case. The nailing down of doors and windows, especially in the places of worship, depicts the city as a crucified

victim or as one giant coffin. The boards on the houses unmistakably look like crosses. On the other hand, in his programmatic attempt to salvage the Revolutionary ideal and separate it from the horrors of the war, Askol'dov makes sure that, uniquely for Soviet cinema, the enemy remains unseen, which renders it unreal, either symbolically or mimetically. The town is also eternally empty, which speaks to its internal nature, independent of the external forces. The film never breaks this apocalyptic barrenness.

We switch back to the Magazaniks. With the same absent-minded smile, the grandmother is observing what is happening: Efim is boarding up the gates of the house; Maria and Vavilova are helping him. As in Grossman's story, he praises this interim period between the armies as his favourite, when he does not have to worry about pogroms or paying the new taxes. Maria, in her usual fashion, puts him down while he, accusing her of constantly looking outside trying to find someone, slaps his wife on the cheek. It seems that he is suspecting her of prostitution or adultery. Vavilova is unnerved by what she sees. Efim clutches the weeping Maria by her cheekbones and yells that no matter who comes into town, he will be the one to pay. The grandmother closes her ears and is terrified. One suspects that it is not the first time she witnesses Efim assaulting his wife. How does one interpret Efim's behaviour? This outright expression of violence (which the script unsurprisingly omits) adds a powerful, even unpleasant, depth to his character, and shows him to be unhinged, suffocated by his lot as a perpetual victim. To paraphrase the title of Pedro Almodóvar's *Mujeres al borde de un ataque de nervios/Women on the Verge of a Nervous Breakdown* (1988), he is a Jew on the verge of a nervous breakdown. Will he find a way of escaping his fate?

As Vavilova and the Magazaniks, shot from the back, continue the nailing, the clatters of their hammers turn into the non-diegetic sounds of the rifles and canons. Maria turns around slightly, and outside the gates we see two horse-drawn carts carrying a drunken wedding party. The Jewish violinist from the market plays a joyous tune, which blends with Schnittke's non-diegetic ghostly and alarming score. Following the film's apocalyptic logic, in visions, the negative turns into positive and vice versa. The surreal wedding procession, passing in the fog by the especially gloomy Trinitarian church and the old fortress, and obscenely revelling in its celebration amidst the overall gloom, is the premonition of the most unsettling segment in the film: the children's pogrom and rape.

THE CHILDREN'S PLAY

The scene, shot not on location but in the studio in Moscow, begins with a close-up of Roza, the oldest daughter, sitting against the wall of the house on a sunny day and looking up above, her shadow visible on the wall. She is an aloof and contemplative child, starkly different from the rest of the boisterous children and out of place in the busy Magazanik house. With her wavy dark hair and big dark eyes, she is the prototype of Jewish beauty. There is silence in the air, interrupted by the almost spooky creaking of the door. Two Magazanik boys with painted moustaches, one holding a toy gun, emerge from the house. The third boy, also sporting a painted moustache and pointing a toy gun, announces in a loud voice, as if addressing the residents of the occupied town, to come out of their cellars and listen to the Hetman's edict. Roza is supposed to play the part of the 'town' in this game. As the boys march onto her, whispering 'We will now kill you', she slowly moves away, visibly frightened, while holding onto the wall, not unlike her father when scared by the passing cavalrymen. Roza begins to call her mother for help as the boys push her against the duvet hanging outside and poke at her with their makeshift swords. The seemingly if not innocent then at least traditional children's war game turns horrific. One of the boys, whose head is wrapped in a plaid blanket, crushes the soft doll with his foot, maliciously intoning 'You deserve what you get'. Hitting Roza and calling her a 'Yid', the brothers rip the duvet with their swords, causing its down feathers to spill. Roza manages to escape to the corner of the yard, but the boys catch up with her, feathers flying all around them. They do not listen to the sister's pleas to stop, and push her to the ground while getting on top of her. She tries to resist by scratching their faces. The rape associations of this 'game' are unmistakable. Yelling 'Look at whom we've got here', the boys cover her mouth and tear the dress, exposing her not yet developed pre-pubescent chest. 'It hurts', Roza screams, as one of the boys

rips her necklace, and another one hurls the doll across the yard, where it crashes on the ground. In the final stroke of violence, the boys tie Roza to the swing like some sacrificial animal and forcefully set it swaying. In slow motion, the camera follows the upward and downward movement of the swing as Roza's hushed 'Mama, Mama' loudly echoes through the air, mixing with the screeching of the swing. The sound disconnects from Roza and becomes non-diegetic, as if emanating from a mystical external source. With her arms stretched outward to the sides, she resembles a crucifix. The next episode begins with the furious Efim yelling at the top of his lungs at the boys and calling them 'pogromists, bandits, murderers'.

The scene is deeply unnerving in its graphic detail, and to the contemporary viewer can verge on the exploitative. It is not surprising that in the final letter to the studio, Trauberg recommended that the scene be deleted, while Askol'dov thought of it as absolutely crucial. The scene underscores that for him violence on-screen can only be portrayed symbolically or through a substitution. In the script, the game never acquires the shocking dimension, and is clumsily interrupted by the sound of a flying aeroplane. Moreover, the script's Efim does not denounce what the sons did at all.

The Commissar is unique in how it handles the theme of children and war. In the official Soviet ethos, children heroically helped with the war effort, both during the Civil War and World War II. One of the great cult films about the Civil War was *Neulovimye mstiteli/The Elusive Avengers* (Keosaian, 1966). Released as *The Commissar* went into production, it tells the story of a group of teenagers fighting against anti-Bolshevik bandits and then enlisting in the Red Army. In European cinema, René Clément's *Jeux interdits/Forbidden Games* (1952) most famously showed the traumatic effect of war on children's psychology, but ultimately Clément's masterpiece was about how, even when compromised, children's innocence perseveres. Radically different from any of these paradigms, Askol'dov's depiction of the rape/pogrom game is much closer to William Golding's *Lord of the Flies*, published in Russian translation in 1969.[24]

Through its doll imagery, the scene functions as a quote from Pavel Kogan's unfinished poem, 'The First Third', which depicts the massacre of the bourgeois dolls in a Soviet kindergarten in the 1920s. For Kogan, the butchery of the dolls throws the noble idea of the Revolution into sharp relief, turning the Revolution into an 'underestimated pogrom'. Similarly to Kogan, for whom the dolls are a substitute for the bourgeoisie and the Jews, in the scene the doll is a substitute for Roza and the Jews. Askol'dov goes to great lengths to depict the children's violence as rooted in the tropes of anti-Jewish assaults. Most important of these are the rape of Jewish women, and the feathers flying from the ripped duvet that, as Vladimir Khazan's (2001: 106–15) study of the subject has convincingly shown, disperse in practically every Russian text on pogroms. The kids may be playing the Ukrainian militiamen, but it is the Revolution that has the inherent potential and capability to turn into a familiar anti-Jewish onslaught as well. As we remember, it was the Revolution's metonymic *tachanka* that threatened the naked Jewish bodies.

The scene is also fascinating and puzzling in terms of what it says about the internal link between Jewishness and violence. On the one hand, there is a connection between the boys' sexual aggression and Efim's slapping of Maria, which suggests that Jewish masculinity is not innocuous. On the other hand, the fact that it is the children who are exhibiting it – performing it – reveals the unnaturalness and immaturity of the act. Efim's outrage at them shows it to be an aberration. It is very telling that the Jewish boys can tap into their violent desires only when pretending to be gentile anti-Semitic bandits. Askol'dov wants the internal Jewish nature and character to remain pure, and for the Jews to be victims rather than fighters, untainted by the violence inherent in history and the Revolutionary mythology. As Omer Bartov (2005: ix–x) reminds us, 'from its very beginning, the cinematic representation of the "Jew" [...] has revolved around the status of the "Jew" as either perpetrator or victim, hero or anti-hero'. Despite Askol'dov's complexity and idiosyncrasy, he fits into this paradigm. The subsequent two scenes solidify the view of the Jew as the victim, and finally bring the mimetic and symbolic Jewish registers together.

IN THE CELLAR

Efim's condemnation of the children's 'game' takes place in the cellar, where the entire family, Vavilova and her child have gathered to hide from the invaders. The third key symbolic episode – after the birth visions and the ruined synagogue – will take place here. It is, however, unique in that the symbolic and the mimetic registers in this episode fully intersect for the first time in the film. Frightened by Efim's fury, the boys are crying. The *mise-en-scène* is circular, with everyone sitting around the bare cellar floor, while the diminutive Efim stands in the middle. As at the end of Grossman's story, he heats the Primus and sits down. The familiar solitary candle is flickering on a chair in front of Maria; cannon thunder is heard outside and the camera zooms in on the candle. Roza is sitting next to Vavilova, who is mending the necklace torn by the boys. Vavilova identifies the cannon sound as 'three-inch calibre' and takes a deep mournful breath. Her body is in the Jewish basement, but her mind and heart are with her fighting comrades.

With a slight benevolent smile on his face, Efim sits across from the commissar. By descending into the basement to be shielded from the incoming pogrom, Vavilova seems to have fully succumbed to Efim's dichotomous 'the world against the Jew' view of history. A Rembrandt-like painting comes to life on-screen: against the blackened background, the figures of Vavilova and the family assume shade-like features, with only their faces lit. If before, Vavilova always cast a shadow – her essence – her illuminated face now projects it; the same is true of Efim. The symbolic has entered the mundane. What ensues is a debate between the Jew and the commissar, the first and only time in the film where Vavilova feels obligated to retort to Efim's soliloquies. Both Babel''s and Grossman's intertextual strands fuse in the scene, as Efim's and Vavilova's conversation will allude to the dispute between Gedali and commissar Liutov in *The Red Cavalry*. The setting comes from 'In the Town of Berdichev', where 'the townsfolk were all in their cellars and basements. Their eyes closed, barely conscious, they were holding their breath or letting out moans of fear' (Grossman 2010: 30).

Efim opens the discussion by revoking his previous dream of the trams running in his town by serenely telling Vavilova: 'In our town there will never be trams'.[25] In response to her sincere 'why?', he intones, 'because there won't be anybody to ride in them'. His tone is uncharacteristically calm and assured. The tram is both a prominent trope in twentieth-century Russian poetry, standing for an existential angst, produced by modernity, and the emblem of Soviet industrialization (Monastireva-Ansdell 2006: 247).[26] Efim's comment taps into both. It is also ironic, since in his town – the apocalyptic Jewish den – there are no people now, as made abundantly clear by the diegetic language of the film. Efim's response to Vavilova is rooted in his experience as a Jew: new bandits will come and put an end to us all. Visibly disturbed, Vavilova gets up, removes her baby from the crib and tries to comfort Efim. She is preparing for a rebuttal.

The rest of Efim's speech starts laying out the groundwork for the next scene's Holocaust vision. To make his point about the destructive continuity of Jewish history and its eventual collapse, Askol'dov resorts both to Babel' and the memory of Nazi atrocities. Efim sorrowfully recounts how Ataman Struk, the Cossack leader, cut his brother's beard with scissors and then decapitated him. Babel''s Gedali also tells Liutov about the Pole who 'grabs the Jew and rips out his beard' (Babel 2002: 228). To the post-Holocaust viewer, the story conjures up documentary footage of SS soldiers doing precisely that to Jews in Warsaw and other places. As we shall see, Askol'dov undoubtedly drew on documentary and photographic images linked with the Holocaust. It is worth recalling here Trauberg's statement – 'I don't need a film about the sad fate of the Jewish people' (Stishova 1989: 117) – which, as I have suggested, was at least partially a reaction to the new image of the Jew created by the Israeli victory in the Six-Day War, which provided an alternative to the helpless victimhood of Jews conjured up by Efim.

Listening to his horrific tale, Roza begins to cry and Maria begs Efim to stop. She calls him '*zloi*' [angry, or evil], the same adjective that was used to describe Vavilova at the beginning of the script. Efim is irked by this misapprehension. He professes himself to be the believer in an 'Internationale of kindness'. He dreams of the day when people will be able to live where they want to live (which to the Soviet Jewish viewer could sound like a call for emigration), and when the

Pale of Settlement would not be confined to basements (meaning that it should be preserved in other forms). Clearly, Askol'dov was still looking for it in Ukraine in 1966. Maria again asks him to stop and he, in a tone of deep anguish, like a tragic character at the end of his rope, exclaims: 'Let me talk, at least this once!' Evoking Chekhov's despondent characters, particularly Doctor Ragin toward the end of 'Palata No. 6'/ 'Ward No. 6' (1892) when he is about to be taken to an insane asylum, Efim utters: 'Amidst the daily cares and concerns, when either you're burying someone or you're being buried, there is absolutely no chance to talk with a fellow human being'. Hinted at in Efim's grief are the dashed hopes of the Soviet intelligentsia during the last days of the Thaw. Efim recalls how everyone was upset when the Turks killed the Armenians, and wonders if anyone will care about the disappearance of Efim Magazanik. This rhetorical question, addressed to Vavilova, whom he properly calls 'Comrade commissar' for the first time, ironically invokes the Holocaust yet again. The world did not care about the Armenian genocide (1915). On the eve of the war, Hitler (in)famously opined: 'Who, after all, speaks today of the annihilation of the Armenians?' As a comic relief, the grandmother sarcastically quips in Yiddish, 'How jovial', and Vavilova begins her rebuttal.

She identifies Efim as a kind and naïve proprietor, and labels his 'Internationale of kindness' the dangerous fairy tales that obfuscate the bloody struggle that the Revolution necessarily entails. Her description of the Revolutionary struggle, delivered as a modernist poem – 'battles, excursions, lice/ Lice, battles, excursions' ['*boi, pokhody, vshi/ vshi, boi, pokhody*'] – is powerful and convincing, as Askol'dov intended it to be. Vavilova, here more a Bolshevik Athena (the Greek goddess of wisdom and craft) than a Madonna, justifies noble evil – hatred of the enemy – that the Revolution generates in its adherents. Efim circles back to the fairy tales of kindness which humanity desperately needs to live, while Vavilova demands the ultimate sacrifice for Revolutionary truth. Channelling the Bolshevik messianic reality, she breathlessly proclaims, 'We shall live! And there will come on earth the union of all working people!' In the foreground, she appears especially outsized and grim; Efim, in the background, is expressly diminutive and sombre. He is not convinced. He brings the commissar down to earth and calls her 'tired'. She agrees, but what he does not get is that her fatigue is epic: the burden of Revolutionary faith is heavy. He, of course, is tired also of carrying the burden of Jewish victimhood. At this moment, out of nowhere, Roza asks Vavilova about her husband. Vavilova responds that he was killed in battle. The main actor in her apocalyptic visions, his mention deepens the flow of the symbolic register into the mimetic.

In the debate, in true apocalyptic fashion, Vavilova stands the conventional morality of good versus evil on its head. For the sake of the Revolution and the future redemption, evil becomes a justifiable and righteous tool. Efim, the *schlemiel*, upholds kindness and the supreme value of non-militant combat against evil through imagination and wishful thinking. Thus, both Efim and Vavilova become archetypes of their respective mythologies. This happens to a large extent through Askol'dov's dialogue with Babel'. In *The Red Cavalry*, the debate between Gedali and Liutov is much less abstract and rooted in the history of the moment. In response to Liutov's solipsistic logic of 'The Revolution cannot not shoot […] because it is the Revolution', Gedali responds with his common-sense ethical syllogism:

A good man does good deeds. The Revolution is the good deed done by good men. But good men do not kill. Hence the Revolution is done by bad men […]. And so all of us learned men fall to the floor and shout with a single voice, 'Woe unto us, where is the sweet Revolution?'

(Babel 2002: 228–29)

The *tachanka* and the children's pogrom play scenes confirm Gedali's words from the Jewish vantage point. Babel' pits the commissar Jew against the traditional Jew, while Askol'dov erases the history of Jewish involvement in the Revolution. Whereas in early Soviet and later socialist-realist literature the Jewish commissar is a prominent type, there is no Jewish alternative to Efim's position in the film. In life, Askol'dov's own commissar father – whose Jewishness the son erased from his biography – represented it. There is also no Bolshevik alternative to Vavilova's new ethics.

Remarkably, in the script Vavilova says to Efim, 'I, too, am for the Internationale of kindness […]. But I am evil. And I never met kind people in the trenches. I'm evil, evil, evil […]. Am I evil, Efim? (Askol'dov 1965: 95). This is not an expression of Revolutionary morality, but confessional self-condemnation and self-doubt. The sentiment in the script is much closer to the epoch's vision of 'socialism with a human face' compromised by the war. The screen reverses it and turns into an unequivocal militant stance. The audience may certainly wonder which side they are on and which side has the upper hand – Efim's or Vavilova's. If Vavilova prevails, is Efim the enemy, and vice versa? The instability of this proposition and the positioning of the Jew as the protagonist or even the hero shows *The Commissar* to be unprecedented for its era. Similarly to Babel', who made the moral debate about the Revolution an internal Jewish issue, other films of the 1960s made it an internal Revolutionary issue. In them, the humanistic challenge to virtuous fanaticism came from within, namely in the context of the justified Civil War. Thus, the official mythology was not demolished, but altered just enough to be acceptable to both the authorities and the new intelligentsia. The solitary 'evil' rigidity of Vavilova, who expresses no concern for an individual human life; the absence of a visible White enemy; and the fact that an ideologically suspect Jewish sage, branded by Vavilova a 'proprietor', may hold the high moral ground explains in part why *The Commissar* languished on the studio shelf for twenty years.

DANCE

The debate ends inconclusively, though to the censors it seemed certain that Efim had won. Outside, the racket of weapons and explosions grows louder. It sounds as if there is an air raid, which imbues the scene with a World War II, rather than Civil War, atmosphere. Everyone in the cellar is frightened, including Vavilova, who, like Maria, anxiously clutches the child. The boys begin to bawl and Efim, holding a candle, picks them up one by one, puts them on the floor to stand in a circle, and begins a finger dance, shot from a high angle, whose movements are borrowed from his earlier jovial dance to the morning. Humming a Yiddish melody evocative of Maria's wordless lullaby, he moves first his index finger and then the entire palm in a circular motion. The kids, now joined by Maria and Roza, parrot him. Their crying turns into laughter. Schnittke's non-diegetic *klezmer*-like soundtrack is jovial, slowly increasing in tempo. The Magazaniks are circling a little stool with a burning candle on it, and the dance turns eerie and grotesque. It seems that they perform some sort of a mystical rite. Vavilova intently watches them. As in a pantomime act, her facial expression fluctuates between fright, bewilderment and pity: she is terrified of joining their circle and yet wants to yield to it at the same time. As if on a wild Ferris wheel ride, the children, one by one, pop up from the bottom of the frame and exit it. As they descend, their arms remain visible amidst the blackness, taking on lives of their own. The whole set-up resembles a marionette theatre. After Maria's appearance on the dance conveyor belt and her enticing arm slowly leaving the frame, the soundtrack breaks down and turns cabaret-like, beautifully representing Schnittke's polystylistic aesthetic. Efim emerges, happily announcing to Vavilova, 'there will never be trams in our town'. His twirling arms vanish, and now it is Roza's turn to call on her to join them. All the arms beckon Vavilova to come inside the circle.

The dance scene is compositionally brilliant and innovative, and it is also of paramount importance for the film's symbolic register. If during the debate Efim was despondent over his fate and yet hopeful that one day the Internationale of kindness would prevail, here he and the family accept their doom with glee. The dance is the expression of their absurdist embrace of their existential cul-de-sac. It also invokes the art of modernist Yiddish theatre. In his essay on Solomon Mikhoels, Osip Mandel'shtam noted in 1920:

> All the power of Judaism, all the rhythm of its abstract dancing thought, all the pride of its dance, whose only reason after all is the compassion toward earth – all of this goes into the trembling hands, into the vibration of the thinking fingers, animated, like human speech.
>
> (Mandel'shtam 1993: 448)

In *The Commissar*, this 'vibration of the thinking fingers' celebrates and embodies death. As if in a traditional *danse macabre*, where personified death lures the living into the realm of the dead, the Magazaniks perform an analogous ritual with Vavilova. In the scene, death for the first time becomes the essential mark of Jewishness. The motif of hands, which in the morning episode exemplified Efim's ritualistic union with the world, here acquires a reverse meaning. In the script, the scene was completely different: Efim turned on an old gramophone and the children were comforted by the music; Vavilova was mesmerized by their dance, but there was nothing symbolic or morbid about it.

According to Andrew Barratt (2001: 157), the scene alludes to the dance of the masked *oprichniki* in *Ivan the Terrible, Part II*. We should also recall that in Antonioni's *L'éclisse/The Eclipse* (1962), a dance was equally symbolic, the sign of Eros and Thanatos. Most provocative, I would suggest, are the parallels between *The Commissar*'s death dance (or *pliaski smerti*, to use the Russian term, and *toytntants*, to use the Yiddish one) in the Polish Yiddish film *Der Dibuk/The Dybbuk* (Waszyński, 1937), produced on the eve of the Holocaust. An adaptation of Semen An-Sky's famous play, it contained a number of wedding dances, one of which featured a bride beckoned by a death figure and finally embraced by it. Whether or not Askol'dov knew of the film or An-Sky's play (staged by the Moscow Hebrew Habima Theatre in 1922), he taps into a similar poetics of Jewishness as the death zone. In the 1920s, however, this view went hand in hand with the programmes of Jewish artistic and political revival, acquiring a deeply pessimistic and fatalistic outlook in the late 1930s. With only a tenuous yet intuitively strong link to this cultural heritage, and operating in the post-Holocaust world, Askol'dov constructs his own mythology, which leaves the Jew no exit from his confrontation with death.

'PROCESSION OF THE DOOMED'

The film's symbolism reaches its apogee in Vavilova's revelation. The mimetic veil is fully lifted and she becomes a Cassandra transported into the future. Instead of the cellar, we suddenly see a procession of Jews – men, women and children – dressed in black, with six-pointed stars on their clothes. The Magazaniks are among them. Efim is foregrounded. He continues to wave his arms; his facial expression is almost blissful, as is Maria's. The grandmother wears her usual absent-minded smile. Some in the crowd are curiously observing the surroundings.[27] No one is crying, or screaming, or trying to escape. The non-diegetic soundtrack is grim, dominated by trumpet sounds. The light in the scene is bright; a reddish hue envelops the screen and what transpires appears to be in a haze. Four men wearing Jewish star armbands drag a coffin with the same star on the cover. The violinist from the market and wedding procession scenes follows it; he plays a joyous *klezmer* tune, which dissonantly mixes with the non-diegetic melody. Strangely, there are women in traditional Ukrainian garments behind him.

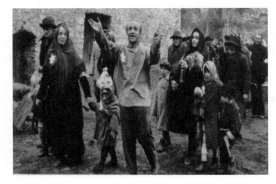

Figure 23: 'Procession of the doomed'. Still from the film.

The Jews walk under an arch into the courtyard of a large open stone structure. The non-diegetic score, composed by Schnittke in 1987, turns grandiose and mournful, with a singing choir and sporadic church bells. There is a close-up of women's stoic faces clad in kerchiefs.[28] As the camera slides up the stone wall, we first glimpse their feet and then, in a wide shot, numerous inmates in the striped uniforms of the concentration camp standing on platforms around the unroofed top. Inexplicably, one of the prisoners is holding a cat. Above them, smoke rises from the adjacent tower. There is a shock of recognition or discovery on the part of the audience, evocative of what the Soviet and Allied photographers and cameramen experienced as they entered the hell of the liberated camps. In fast motion (in the apocalyptic framework, time speeds up) the rest of the Jews pass under an arch and proceed into the barracks' quadrangle. Vavilova is behind them, and behind her there looms a lonely leafless tree with just a few naked branches. In a classical Madonna pose, she clutches the child. The camera closes in on her and she walks under the arch. All the Jews inside, standing with their backs to her, slowly move their raised arms. Vavilova turns around and peers intently and sadly into the camera, reminiscent of the Madonna statue at the film's start. Unlike the Christian Madonna, however, she does not hold out the child to give him to the world, nor do we see the child's face.

The scene's explicit Holocaust imagery is unmistakable. To shoot it and present to the studio in 1966/67 required extraordinary courage and conviction. The censors found it utterly unacceptable. Askol'dov, who today identifies the Holocaust as one of the chief artistic themes (personal communication April 2015), thought of it then also as the most important part of *The Commissar*. In it, the film's grand symbolic motifs coalesce to give voice to his ultimate expression of the poetics of Jewishness. To appreciate the scene, its historical and aesthetic contexts need to be considered. The two main strategies of obfuscation and universalization coloured any official discussion of the Holocaust in the post-war Soviet Union. The specific destruction of Jews as Jews was erased from historical and artistic reflections on the war, which concentrated, on the one hand, on the plight of Soviet people as a whole, and, on the other, glorified Russian heroism. During the Thaw, a number of officially published literary works in Russian, both poetry and prose, did address it, making the Holocaust legacy the most pivotal and contentious issue of the era.[29] Most importantly, outside the official channels, the Holocaust loomed large in unpublished literature and Jewish memory practices.

Askol'dov's Holocaust project grows out of this context, especially regarding his link to Grossman. Grossman's report on the death camp Treblinka was included in the 1958 collection of stories that featured 'In the Town of Berdichev'. In defending the scene in 1967, Askol'dov specifically invoked Grossman's 'anti-fascism' (Gershenson 2013: 167). Equally pertinent is the cinematic context: the scene employs elements which by that time had become exemplary icons in cinematic representation of the Holocaust, such as the procession of Jews to the ghetto, the incorporation of diegetic and non-diegetic music, the crematoria's chimney smoke and yellow stars. While the procession to the ghetto trope largely came from Polish films, some of which were discussed in Soviet scholarship of the time (Markulan 1967), the others were made prominent by Soviet, Polish and western documentaries about the camps. Two Soviet films are also important here: *Nepokorennye/The Unvanquished* (Donskoi, 1944), which remarkably for its time featured the procession of Jews to a killing site, Babii Iar in Kiev, and their massacre there; and the documentary *Obyknovennyi fashizm/Ordinary Fascism* (1965), filmed by Askol'dov's teacher Mikhail Romm, which presented an enormous amount of Holocaust footage, although not discussed as such. Askol'dov mixes up the procession and death/labour camp imagery to produce a deeply symbolic and idiosyncratic *mise-en-scène*, one that is both problematic and inspiring.

The location sets the stage. The 'camp' structure is the Russian Gates of Kamenets-Podol'skii's Old Town, located at its south-western end. Built in the sixteenth century, the gates constituted a unique, elaborately fortified network of towers and hydraulic gateways. By locating the scene in this overpowering premodern edifice, the film detaches the Holocaust from its immediate historical context, turning into an event that equals the destructive magnitude of history as a whole. According to Valerii Ginzburg, the gates were chosen because they 'resembled a furnace, an enormous oven from which there is no return' (Ermakova 1990: 12). Ginzburg recalls how he used smoke and lens

shades to differentiate the scene from the rest of the film. According to him, the reddish hue was added when *The Commissar* was reconstructed in 1987. What is remarkable – and this again speaks to how the city itself supremely shapes the film's symbolism and content – is how the gates, especially via the arch element, resemble the ruined synagogue, visited by Vavilova during her own procession. It should be remembered that Ginzburg was invested in capturing the continuity of the stone structure of Kamenets, which, as noticed by Lev Anninskii, recalled the 'apocalypse of World War II, of Stalingrad and Auschwitz' (Anninskii 1991: 227).

The synagogue metamorphoses into a camp, suggesting that Jewish sacredness carries its destruction within itself. Thus, the very essence of Jewishness, its perpetual ruin, finds its utmost manifestation in the Holocaust. The camp becomes the ultimate Jewish reality, similar in its function to the visions of messianic Revolutionary reality of Vavilova's birth pangs. The film's motif of arches finds its full realization here as the entrance into the death zone. In line with *The Commissar*'s overall principle, there are no perpetrators here: the Jews are driven into the gates of death as if by their own volition. They, and especially Efim, are in their natural element here. Even the title Askol'dov used for the scene – 'Procession of the doomed' – signals that he views the Holocaust as inevitable and somehow preordained. If earlier Holocaust films, such as the Polish *Ulica graniczna/Border Street* (Ford, 1948), emphasized both Jewish martyrdom and resistance, Askol'dov presents the Jews as engaged in a self-destructive ritual that only they can comprehend. The totem here is the coffin with the Jewish star – the very symbol of Jewishness as death.[30] At the end, with their synchronically waving arms, the Jews operate as the living dead in a trance. We can presume that they will be gassed and turned into the smoke that emanates from one of the towers. Ultimately, however, this is beside the point. Askol'dov freezes them in the moment, in the symbolic limbo zone where they are already lifeless and yet perpetually lingering.

Of course, all of this is seen through Vavilova's prophetic gaze. The audience, be it in 1967 or 1987 or today, knows that the vision is true because of history, which confirms Vavilova's providential nature and the authenticity of her previous apocalyptic experiences. Standing in the arched entrance to the camp, she repeats what she did earlier when poised in the arch window of the synagogue, at the close of her own procession: she curiously and sympathetically observes the Jewish realm from her privileged vantage point, and then takes her leave of it. The two symbolic zones of Jewish destruction and the potential apocalyptic Revolutionary redemption do not mesh. In this, Askol'dov radically sets himself apart from Babel', in whose Bratslavskii, the last prince of the Hasidic dynasty and the Red Army warrior, the two universes fuse. Instead of the Holocaust documentaries' 'singularly unbearable image […] the stare into the camera' by the survivor who says, 'I have returned from the dead. I have stared death in the face' (De Baecque 2012: 43), Askol'dov offers his own stare into the camera: that of the Bolshevik prophetess and Madonna.

There is one final fascinating element to the Holocaust episode. According to Askol'dov, when he began shooting it, some local Jews cast as extras stopped in their tracks, began to cry and refused to move (Askol'dov 2004a). The reason, Askol'dov explains, is that on this spot the Germans massacred the Jews in 1943. He begged them to proceed and they finally acquiesced (Ben Natan 2012). In an almost supernatural manner, history intruded into the production. But did the massacre indeed occur on this spot? The so-called 'Holocaust by bullets' took place in the Soviet Union when the Nazis exterminated most of the Jews on the outskirts of towns and cities where they lived, often in ravines. This is what is depicted in a highly stylized fashion in *The Unvanquished*.[31] The first such large massacre in the occupied Ukraine took place in Kamenets-Podol'skii, where in late August 1941, the Germans killed approximately 24,000 Jewish men, women and children, 14,000 of whom were deported to Kamenets from Hungary. In November 1942, the Germans exterminated 4000 inmates of the Kamenets ghetto, putting an end to seven centuries of Jewish presence in the city. All of these atrocities took place by the old munitions depot area and the nearby Jewish cemetery, located at the north-eastern end of the Old City, and thus at the opposite end from the Russian Gates, the site of the film's camp.[32] By the munitions depot is also where the remaining Jews, who were able to escape earlier, were shot by the Germans in 1943, on the eve of the city's liberation by the Red Army in March 1944. The sites of the killings were identified by the Jews who returned to the city at the end of the war. Despite the

regime's opposition, they were able to erect monuments there, with inscriptions in both Yiddish and Russian, and the date of the massacre according to the Jewish calendar. Such was the actual geography and legacy of destruction in the Kamenets 'bloodlands', to use Timothy Snyder's (2012) loaded term. As an artist, Askol'dov constructs anachronistic associative chains that mark the continuity of Jewish persecution. By mistakenly claiming that the slaughter took place at the foot of the symbolic camp, he forcefully and imaginatively roots his cinematic vision in the historical ground, re-enacting the Holocaust not just on-screen, but also, as it were, in the 'real' life and times of 1943 and 1966.

THE END: THE JEWISH DEAD AND THE BOLSHEVIK SAINTS

The vision abruptly ends and Vavilova finds herself again in the cellar. She observes the peacefully sleeping Magazaniks. The non-diegetic soundtrack is the voice of an old woman, presumably the grandmother, intoning a Hebrew prayer. As the camera focuses on the familiar isolated flickering candle, the soundtrack switches to a Russian translation of the prayer, also said by an elderly woman, who speaks Russian with a Yiddish accent: 'O Lord, do not hide your face on the day of our affliction. Hurry to hear our supplication!' As Olga Gershenson (2013: 258) has pointed out, '[t]he Russian text is not a translation of the Hebrew, and the Hebrew, unlike the Yiddish, is inauthentic'. There is a contrast between the veracity of Vavilova's vision and the poignancy, but also the inefficacy, of the Jewish prayer. As the sound of the prayer dies down, Vavilova disappears into the darkness of the cellar. She ascends from it into the light and fog of the morning, visibly happy to leave the Jewish death zone. As she sits by the nailed doors of the house to comfort her infant, she hears the marching boots of the Red Army cadets. Agitated, Vavilova runs up to the gates of the Magazanik courtyard and peeks at them through the crack in the fence. In addition to the soldiers, a throng of beautiful dark horses, signs of the Revolutionary messianic age, passes by the house. It is at this point in both Grossman's story and the script that Vavilova experiences an epiphany: the vision of Lenin speaking at a large rally. On-screen, the horses, who migrate from her apocalyptic birth visions, represent once again the confluence of the mimetic and symbolic realms. Through seeing them, Vavilova is reborn as a commissar.

Like the biblical Samson, she acquires extraordinary strength: she places the baby on the ground and removes the boards nailed to the front door. Once inside, she rushes into her room and finds her uniform. As the cadets continue to march outside, she tries to breastfeed the child. She asks him to grow strong and be careful: not to run outside the gates where he could be trampled by horses. In doing so, she imagines a Jewish fate for the child. Weeping, she

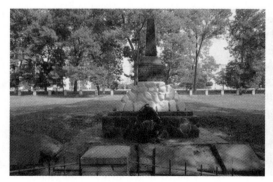

Figure 24: Holocaust memorial with an inscription in Yiddish, Kamenets-Podol'skii. Photo courtesy of Anna Kupinska.

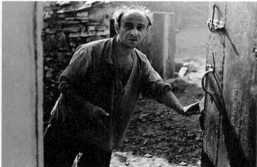

Figure 25: Magazanik screaming after Vavilova. Still from the film.

also tells him that his father's name was Kirill and that he is named after him. According to Margolit (2012: 534), this name makes Babel''s Kirill Liutov the father of the child. Yet the swarthy warrior from Vavilova's earlier vision is hardly the feeble Liutov. Finally, Vavilova swaddles the baby and kisses him, holding the belt with the gun holster in one hand. She exits the house and yells for Maria. The scene switches to the town square, marked by its synagogue and church, where her regiment's officer whips a horse and finally lets it gallop away. Does this suggest the release of the messianic steed into eternity, or the failure of the Red project? Or does the film mechanically replay its motifs until they lose all fresh meaning?[33]

We are back with the Magazaniks. It is now the still sleepy Efim who ascends from the cellar. Unlike Vavilova, he is bothered by the morning light, as was Emelin who ascended from the basement to be tried by Vavilova and be shot. Efim searches for the commissar and instead finds only the infant. Maria, dressed in funereal black clothes, joins him, and Efim announces that she has gone. With the child in his hands, he rushes to the gates, not unlike Vavilova earlier, and screams for her, 'Klavdiia! Klavka!'. More than anything else, this usage of the nickname reveals the utter disconnect between them. Completely oblivious to her prophetic nature, Efim ultimately sees her as a lowly Russian peasant woman. His last words are, 'What a people, Maria', which can either convey admiration or sheer incomprehension and aversion. Both in the script and the story, Efim calls them 'real people', while he and his brood are 'manure'.

The camera leaves the couple and shifts to Vavilova, running breathlessly through an empty cobbled Dovga street. Her facial expression is keen and determined. As we see the soldiers' boots marching through the mud, the 'Internationale' begins to play non-diegetically. One soldier, dressed in a white uniform, carries the red banner of the Petrograd cadets. The banner, with a hammer, sickle and the five-pointed star visible at the centre, flutters in the wind. Behind him are a few other cadets moving forward with rifles, ready for battle. As always, the enemy is invisible. Now a few more of them appear, as well as the officer from Vavilova's regiment. In a wide shot, they all march in a snowy field in the distance, with Vavilova at the vanguard. The town is behind them. As they come closer, some of them look admiringly at the sky. There are explosions ahead of them, but they keep on moving. Finally, the camera recedes again and, in slow motion, we glimpse the remaining few cadets, once more led by Vavilova. The camera cuts away, leaving them in perpetual motion.

The snow is falling on the empty Magazanik yard, perhaps evoking the snow blizzard in Bulgakov's *White Guard*. The dogs bark and the wind whistles. The last image of the film is the bare snowfield, where Vavilova and the cadets just marched. The town is nothing but a few almost indistinct shadowy towers in the background. The wind continues to howl and the church bells chime.

Much in the overall understanding of the film depends on how these last scenes are interpreted. The key questions are: why does Vavilova leave the child with the Magazaniks and what is Askol'dov's ultimate commentary on the Red cause? In Grossman's story, we never see Vavilova actually rejoining the troops. The last sentence is the inconclusive: 'The cadets disappeared around a turn in the road'. In the script, Vavilova is marching with them, thinking about her son. She mentally links the cadets with him, and it is clear that she is returning to battle for his sake. Finally, she sings a song with her 'soft female voice' (Askol'dov 1965: 104). Thus, her femininity, motherhood and commissar identity are harmoniously reconciled. Also, while the film ends with the images of the snowy landscape, in the script it is a hot summer.

The film offers a radically different aesthetic and resolution of Vavilova's crisis, which intensifies Askol'dov's portrayal of the Revolution as a religion, and fully divides the Jewish and Red realms. It is crucial that if in 'In The Town of Berdichev', the Magazaniks spot Vavilova 'running down the street after the cadets, slipping a cartridge clip into her large gray Mauser' and do not take their 'eyes off her' (Grossman 2010: 32), on-screen, they never see Vavilova again. Both remain closed off in their mimetic and symbolic quarters, with only the child connecting them. It is certain that in the symbolic and ideological context of the film, the messianic nature of Vavilova's son needs to be taken seriously. Vavilova is not an allegorical but an actual prophetess, who knows that she is signing the child's death sentence by leaving him with them. Thus, there is a sacrificial Christ-like element to his fate. But is there a redemptive one?

The key is that Askol'dov links the anti-Jewish violence and the Revolution throughout the film. The censors were right to notice that the Holocaust 'procession of the doomed' is a 'symbolic scene', which 'insinuates' that 'the seeds of inequality and anti-Semitism, which brought people to the death camps and World War II, were sown during the Revolution,' (Fomin 1990: 11). Thus, they accusatorily, but again rightly, concluded 'the film [...] underscores the unique mission and suffering fate of the Jewish people' (1990: 11). Cleansing the Revolution of its pogrom smell so that it would not turn into an 'underestimated pogrom' is Askol'dov's paramount obsessive question, and the very reason for the Holocaust vision as well as the film's creation of the Red and Jewish mythologies as a whole. His solution is to make the Revolutionary messianic infant a Jew by fate, rather than by blood or name. The Jewish fate may be lethal, but it is ennobling. Askol'dov seems to be thinking along the same lines as the American poet Muriel Rukeyser, who wrote in 1944:

To be a Jew in the twentieth century
Is to be offered a Gift. If you refuse,
Wishing to be invisible, you choose
Death of the spirit, the stone insanity.
Accepting, take full life. Full agonies:
Your evening deep in labyrinthine blood
Of those who resist, fail, and resist: and God
Reduced to a hostage among hostages.

(Rukeyser 2004: 103)

The messianic child, who will die as a Jew, ensures the longevity and purity of the Revolution, but he cannot change the essence of Jewish history. Miron Chernenko, a scholar of Jewishness in Russian cinema, has perceptively commented that in *The Commissar*:

[Vavilova] supernaturally grasps [...] that in Jewish history there is no chronology [...] it exists only in space, moving from one geographic location to another, until all these points become one at the moment of the coming of the Messiah [...] in the Promised Land.

(Chernenko 2006: 229)

There is nothing, however, in the film that points in this redemptive Judaic messianic direction. The Magazaniks' volatile and at times joyous existence is merely an episode within the Jewish continuum of emptiness and decay, where the perpetually ruined synagogue blends into the death camp. In a radical departure from Grossman (who insists on the longevity/survivability of the Jew) and Babel' (who, even in *The Red Cavalry*, not to mention his diary, invokes the heydays and regenerative cycles of Jewish history), Askol'dov paints Jewish existence as inherently and essentially lethal, rolling along on its own fatal course. Not grounded in any specific Jewish tradition, Efim's 'Internationale of kindness' is completely subsumed by this ethos of death. Ultimately, *The Commissar* upholds Vavilova's humanly warm and ideologically rigid branding of Efim as 'a good man, but a proprietor', whose historical vision is clouded and for whom there is no place in the Marxist utopia.

According to Margolit (2012: 536), the film's last images offer a requiem to the Revolution, which failed because it did not take into account the value of every individual life. However, Askol'dov's aestheticization of the Revolutionary struggle suggests otherwise. The concluding shots of the remaining few Reds led by Vavilova, with the 'Internationale' on the soundtrack, are solemn but not sad. They function as a redeeming icon rather than a requiem. In the consistent absence of any visible enemy, maintained up to the conclusion, the film asks the viewer to believe in the Bolshevik Revolution as a mythology in its purest form, unaffected by history and biology, and living

in an aesthetic symbolic reality. We may presume that Vavilova and her comrades mimetically perish, which only enhances their self-sacrificial Revolutionary credentials and aligns with the Soviet cinematic ethos of the Civil War. Nevertheless, being no longer accessible to the camera's eye, they symbolically ascend into the Bolshevik paradise where their horses await them. Askol'dov revives the original Bolshevik apocalypticism, creating characters who are 'the saints of a new type and priests of the Revolutionary cult. The immortality they exhibit is the best proof of the longevity of the new Bolshevik religion' (Kondakov 2001). It is remarkable that he does so while fully cognizant of the destructive extent to which this mythology has been historically compromised.

Jean-Paul Sartre wrote about Tarkovskii's *Ivanovo detstvo/Ivan's Childhood* (1962):

War kills those who wage war, even if they survive it. And, in a still deeper sense: history, in the selfsame movement, demands heroes, creates them, and destroys them, in rendering them unable to live without suffering in the society that they have contributed to forging.

(Dunne 2008: 39)

To mitigate this 'deeper sense' of which he is very much aware, and keep his heroes eternally alive, Askol'dov – the creator of ideological/religious cinema – sacralises them. In the final frozen emptiness, the bells toll for the Jewish dead and the Bolshevik saints.

Chapter 4
1987 and after: Critical reception and debates

THE COMMISSAR RELEASED

A major element of the liberalizing perestroika reforms initiated by Mikhail Gorbachev in the late 1980s was the rediscovery and release of many censored and forbidden films. While, ultimately, *The Commissar* was 'taken off the shelf' as the result of these processes, how this came about was torturous and hardly predetermined. A number of documents from the summer and autumn of 1986 indicate that the authorities had no problem with lifting the ban on *The Commissar*, and in fact called for it to be screened not only in the USSR, but also abroad. They instructed the State Film Committee (Goskino) to allow Askol'dov to make the changes to the film that he deemed necessary, to rework the sound in some of the scenes, and to reinstate him, with financial compensation, to the position of a film director (Arkus 2002: 50). Yet a number of prominent film-makers who opposed the film in 1965–67, such as Sergei Bondarchuk and Stanislav Rostotskii, as well as the head of the State Film Committee, Filipp Ermash, strongly objected to this decision. Accusations of 'dehumanizing' and 'de-heroizing' the Revolutionary legacy again came to the fore, as well as the fresh supposition that the film's emphasis on the 'Jewish question […] could lead to an unfortunate spark in inter-ethnic strife' (Arkus 2002: 54). As a result, the committee decided to essentially re-ban *The Commissar*, the only film to suffer such a fate during perestroika. The euphemistic anti-Jewish sentiment, resistance to reforms and personal animosity toward Askol'dov clearly prompted the verdict. Askol'dov, however, was able to gain access to the only existing copy of the film and proceeded to work on it, along with Schnittke and others, making a number of changes to the soundtrack and colour discussed in the previous chapter.

The breakthrough came during the 15th Moscow International Film Festival in July 1987, which was attended by the luminaries of European and American cinema. At a press conference on 9 July, director Elem Klimov, the head of the Film-makers' Union, was asked by a Brazilian critic whether all banned Soviet films had been released. Klimov gave an unequivocally positive answer. Askol'dov, who was sitting in the audience, stood up and demanded from Klimov that he should be given a chance to speak. Grabbing a microphone from a woman who turned out to be the famous British actress Vanessa Redgrave, he made the following impassioned plea:

> Twenty years ago I made a film about the cancerous tumour in human history – ethnic chauvinism – the main enemy of our Revolution and our society. There are, however, anonymous forces in our society that prevent this film from being shown, even at a venue like this. I think that this is completely wrong and undermines the essence

of glasnost [...] and of the grand programme which our Party has put forth. I ask the presiding committee to allow the film to be shown on this screen.[34]

(Balaian 2006)

These remarks are revealing of the paradoxes and intricacies of Askol'dov: the reformer and the ideologue; the renegade outcast and the entrenched insider. They convey his absolute dedication to the Revolution, and the idea that to survive and flourish it needs to be purged of the malignant anti-Semitic blemish ('chauvinism'), which is precisely what *The Commissar* is about. Askol'dov replicates the typical Soviet language of denunciation so effectively used against him. He now becomes the accuser, calling out those 'anonymous forces' [*bezymiannye sily*] which 'undermine' [*podryvaiut*] the Party's next grand project that he faithfully follows.

According to Askol'dov, the next day Colombian writer Gabriel Garcia Marquez met with Gorbachev, who had earlier opposed the film's release, and told him about Askol'dov's request. Gorbachev gave the green light and *The Commissar* was screened on 11 July 1987 in the White Hall of the House of Cinema in Moscow, where twenty years before it had been banned. On 20 July, by decree of the Central Committee of the Party, the film was approved for release in the extremely limited quantity of seven copies 'in light of what has transpired' (Bossart 2007). Finally, the hand of the detractors of Askol'dov's creation had been forced.

The screening of *The Commissar* in Moscow, and finally across the Soviet Union, in 1988–89 was one of the most important cultural events of perestroika. In February 1988, the film premiered at the Berlin International Film Festival, where it won the Special Jury Prize (Silver Bear), and the Prize of the Ecumenical Jury and the FIPRESCI Jury. The same year, the composer Schnittke, the film's cinematographer Ginzburg, and the actors Bykov and Nedashkovskaia received a NIKA award, the Russian equivalent of the American Academy Award. Notable was also the film's showing at the Jerusalem Film Festival and the San Francisco International Film Festival in 1988, where, according to Askol'dov, there had been plans to screen it in 1968.

SOVIET RECEPTION

Amidst this triumphant return and the uncovering of the film's fate, however, Askol'dov continued to insist that he and his work were not given their proper due. Old grievances also came to the fore. The most public of them was Askol'dov's (1991) piece in one of the major newspapers *Izvestiia*, which stated that Valerii Ginzburg betrayed him during the banning of the film, denounced him to the KGB and had nothing to do with the film's restoration. Ginzburg (1991), whose contribution to the aesthetic of *The Commissar* was enormous, responded in kind, accusing Askol'dov of slander and insisting on his dedication to the film all through the years.

The reception of the film was also contentious. As freedom of speech began to take root in the late 1980s, anti-Semitic sentiments no longer had to be veiled and could be publicly expressed. Thus, *The Commissar* was denounced as the promoter of a 'Zionist' conspiracy in the nationalist and unabashedly anti-Semitic journal *Nash sovremennik*. While some of the liberal figures combated this vitriol, they largely did so by stressing the film's universalism and obfuscating its explicit centeredness on Jewishness. In the late Soviet context, both the liberal and nationalist writers and film-makers were equally wrapped up in their ideological, cultural and religious biases when it came to Jewish issues. Ironically, it was at times the nationalists who drew attention to Jewishness, recognizing in it a separate culture and mindset, while the liberals tended to see any pinpointing of Jewishness as anti-Semitic. This was reflected in the most interesting exchange about *The Commissar*, published in the newspaper *Sovetskaia kul'tura* (Sinel'nikova 1988).

Among the four participants in the discussion, the most provocative statement came from Vadim Kozhinov, a critic in the nationalist camp, who, while bemoaning the film's twenty-year exclusion, found its symbolic poetics to be no longer effective, but belonging solely to its era. The only enduring 'living' aspect of the work, according to Kozhinov, was the character of Efim (Sinel'nikova 1988). Thus, he emphasized the film's Jewishness and devalued its

portrayal of the Revolution. His, however, was a lonely voice. The universalization of the Magazaniks and the erasure of their Jewish specificity became the dominant way of interpreting *The Commissar*. Askol'dov himself, perhaps in reaction to the film's troubled history, began to insist that the film's Jewish characters and locales were merely props in a work that is about motherhood, war, Russia, etc.[35] With its analysis of the film's poetics of Jewishness and contexts, this book has challenged this view.

The perestroika discussion of the film's approach to the Revolution and the Civil War was more perceptive. In the *Sovetskaia kul'tura* exchange (Sinel'nikova 1988), Lev Anninskii argued that *The Commissar* was part of the Thaw re-evaluation and idealization of Bolshevik origins. He concluded that Askol'dov's take on them was tragic and apprehensive, and therefore deeply relevant to the debates about the Soviet past sparked by perestroika. In parallel to the universalization of the Jew, the tragic reading of *The Commissar* emerged as the most influential, as did the idea that it reflected the Thaw principle of 'socialism with a human face', announced by Alexander Dubček in April 1968 and resurrected by Gorbachev in the late 1980s. Unsurprisingly, this early reception of the film was much more about the crucial ideological and cultural debates of perestroika, rather than the work's complexities and idiosyncratic mythologies, which this book has tried to uncover.

WESTERN REACTIONS

The initial western, and particularly American, reactions to the film were mostly positive, the product, by and large, of the general fascination with the changing Soviet Union. The expectations of some of the critics, however, were upset by *The Commissar*. Writing in *The New Yorker*, David Denby opined:

> Given the movie's troubled history, and the heroic persistence of the ornery Askoldov, I wish I could say that it was a great work. But *Commissar* is a mess – a collection of jagged overwrought fragments, some eloquent, some bombastic […]. This simple story is overburdened with huge dream episodes in a hyped-up, clangorous expressionist style – visions of riderless horses, a vision of the Holocaust itself. Presumably it was the sympathetic treatment of the Jews that got the film banned […] yet *Commissar* doesn't say anything openly about Soviet complicity in the destruction of the Jews. In the Gorbachev era, Askoldov […] may be able to make his meanings plainer.
>
> (Denby 1988: 45)

The most fascinating aspect of these remarks is how they mirror the statements of Soviet censors. Tatiana Sokolovskaia, one of the editors at the Gor'kii studio, wrote:

> The film does not have a coherent artistic image. It is woven from stylistically divergent pieces, borrowed from different cinematic traditions: from Dovzhenko to Luis Buñuel to the surrealists. The film is saturated with symbols which are woven into realistic and uncomplicated episodes.
>
> (Fomin 1990: 10)

Askol'dov's aesthetic design, whose elements they identify at least partially accurately, is completely alien to both the American critic and the Soviet ideologue. Askol'dov's meanings are 'plain', but in order to grasp them, the symbolic architectonics of his work need to be appreciated and taken at their face value. Ultimately, Denby seems to inadvertently echo Kozhinov, who described the film's symbolism as old-fashioned and ineffective. As such, the history of the reception of *The Commissar* reveals strange bedfellows.

Askol'dov's approach to the Holocaust and the representation of Jews did not sit well with some other prominent critics. While generally praising the film, J. Hoberman (1988a: 63) called the Holocaust scene 'artless', while *The New Republic*'s Stanley Kauffman (1988: 24), as I pointed out earlier, found the portrayal of Efim – 'what shrugs, what

gestures (always two-handed), what cantorial intonations, what head clutching' – deeply unsettling and cartoonish, despite Askol'dov's and Bykov's intent. In this, he too, like Denby, concurred with the Soviet censors. The chief accuser of the film, Aleksei Romanov, argued that 'the elements of caricature are especially clearly seen in the image of Magazanik [...]. The actor Bykov tries to portray a Jewish craftsman, who came out of a joke [...]. All his jumps and shrugs are borrowed from jokes about Jews' (Stishova 1988: 119). To be sure, there is some validity to both Kaufmann's and Romanov's observations, clearly prompted by very different agendas and sensibilities, but the film's symbolism and mythologizing of Jewishness are discounted by both.

Finally, it is noteworthy that, in the West, Askol'dov (1990: 10) was much more open about his positive vision of the Revolution, without qualifying it, as he did in a Russian interview, as 'the Revolution with a human face'. Thus, he told J. Hoberman (1988b: 61) after the film's screening in Berlin: 'I wanted to make a film about the revolution as a religion'. In an interview with Louis Menashe (2010: 302), he pointed out that his main influences were not only Eisenstein, whom he called the Leonardo da Vinci of his time, but also 'Marx and Lenin'. In a conversation with Judy Stone, he explained that the episode of Vavilova's birth represents:

> [...] the birth of a specific child and the birth of a revolution. A revolution is very hard labor. There is blood and disappointment, a new morality and a new connection between people [...]. In the task of returning morality to society and to return what came with the revolution – something that I personally believe in is a task of first importance and complexity.
>
> (Stone 1997: 514)

Writing about *The Commissar* admirably in *Film Comment*, Anne Williamson was taken aback by Askol'dov's profession of 'faith':

> Though failing as a cynic, Askoldov has succeeded admirably as a faithful, even evangelical, believer in the morality of the Russian revolution. The moments in which the director discusses his faith take on truly surreal quality. 'I'm a believer, the Revolution is my religion,' Askoldov passionately repeats again and again, embracing an ideology in the name of which millions were slaughtered (including Askoldov's father in 1937), exiled, purged, eliminated, snipped out of family photographs, and only occasionally rehabilitated but most often forgotten.
>
> (Wolf and Williamson 1988: 70)

It is, however, precisely because of Askol'dov's faith in the Revolution that he salvages it symbolically and aesthetically in *The Commissar*, dislodging it from the horrific historical reality and the taint of anti-Semitism.

Outside the confines of the internal Soviet and Russian debates, Askol'dov seems also to have been freer in expressing his take on Jewishness. If in Russian he consistently spoke about the film's Jews as merely a backdrop, in an interview recorded in *Cahiers du cinema*, he stipulated that the Magazaniks are not just 'a concrete family, but all of a Jewish family', and Vavilova is not just an individual commissar, but 'the metaphor for Russia' (Reynaud 1988: 24). Thus, he pinpoints the film's two symbolic universes – Jewish and Bolshevik Russian – and his investment in them for their own sake, rather than some universal reason. Yet Askol'dov does not disclose his own Jewish origins in either the Russian or the western interviews, while practically all American reviews emphasize that this film about Jews was created by an ethnic Russian.

Another feature that unites most of the responses to *The Commissar* from this period is the anticipation of Askol'dov's next film:

> In *Film Comment* he [Askol'dov] calls it 'stupefying' that 'after two and a half years of *perestroika*, not a single, deep, authentic intellectual film has been shot in the Soviet Union'. Perhaps that film will be made by Alexei

Gherman or Kira Muratova or Tenghiz Abuladze, three talents who have only recently come to light. But given Askoldov's willingness to push past the limits of the permissible, it may have to wait for *Commissar* II.

(Hoberman 1988a: 70)

This, of course, did not happen. Askol'dov's ideas for the second film, such as the adaptation of his novel about the Moscow Yiddish theatre, never came to fruition.

Reviewing the film in the German newspaper *Die Zeit*, Andreas Kilb (1988) expressed a similar desire: 'When at night in San Lorenzo one sees a shooting star, one must make a wish. For example, for the next film by Aleksandr Askol'dov. The twenty dark years are over'. Kilb wondered how the history of cinema would have changed had *The Commissar* actually come out in 1967 or 1968, 'the year of the cinematic visions of doom', with François Truffaut's *La mariée était en noir/ The Bride Wore Black* (1968), Jean-Luc Godard's *Week-end/ Weekend* (1967), Pier Paolo Pasolini's *Teorema* (1968) and Luchino Visconti's *Lo straniero/ The Stranger* (1967). His response is that nothing would have changed, since *The Commissar*, exclusively in dialogue with the cinema of the 1920s, 'had nothing to do with the experiences, wishes, and hopes of 1968' (Kilb 1988). Yet one of the Soviet censors, A. Akhtyrskii, sharply pointed out in his criticism of the film:

The process of dehumanizing a human being, the erasure of his individuality and of everything that makes one an individual [...]. I saw all this in Orson Welles' *The Trial*, Godard's *Alphaville, Le Petit soldat,* and *The Soldiers,* and many other less distinguished films. And now to my complete surprise I saw a similar sentiment in a Soviet film! [...] According to Askol'dov's film, it was precisely the Revolution that has awakened the horrific destructive forces that brought death and destruction to everything living, 'including' the destruction of the live flesh of the Magazaniks.

(Fomin 1990: 11)

This is a remarkable statement, which insightfully identifies both the frightening apocalyptic dimension of Askol'dov's vision and the Revolution's link with the death of the Jews, and which also ingeniously connects it with Welles' and Godard's poetics. The critic completely overlooks Askol'dov's redeeming sacralisation of the Revolution precisely because it emanates from this apocalyptic dimension very different from the 'socialism with a human face' model.

It is ironic that the censor, whose intent it was to degrade the film, managed to put Askol'dov in dialogue with Welles and Godard, which only intensifies the injustice of *The Commissar*'s twenty-year imprisonment. Imagine this: what if Welles, who certainly had his share of quarrels with the film industry, had made *Citizen Kane* (1941) and could only screen it in 1961? What if Godard made *À bout de souffle/ Breathless* (1960) and had it shown for the first time in 1980? It is thus unsurprising that today, the 84-year old Askol'dov calls his film both his curse and his blessing. He divides his time between Russia, Sweden and Germany, where he continues to teach at the Film Academy in Berlin, and still has a hope of bringing the vision of his second film to life.

Askol'dov insists that only through the 'aesthetic categories of poetics' can *The Commissar*'s 'main content' be grasped (personal communication April 2015). Hopefully these 'categories', which the book has striven to identify, examine and contextualize, will guide any contemporary and future viewings of this remarkable and unique film.

References

Anderson, Mark (ed.) (1989), *Reading Kafka: Prague, Politics, and the Fin de Siècle*, New York: Schocken.

Andrew, Joe (2007), 'Birth equals rebirth? Space, narrative, and gender in *The Commissar*', *Studies in Russian and Soviet Cinema*, 1: 1, pp. 27–44.

Anninskii, Lev (1991), *Shestidesiatniki i my*, Moscow: Kinotsentr.

Anon (2013), 'Munitions depot', http://www.yadvashem.org/untoldstories/database/murderSite.asp?site_id=288. Accessed 20 July 2015.

Arkus, Liubov' (ed.) (2002), *Noveishaia istoriia otechestvennogo kino. Kino i kontekst 1986–1988*, vol. 4, St. Petersburg: Seans.

Aronson, Oleg (2001), 'Nearkhiviruemoe', *Index*, 14, http://index.org.ru/journal/14/aronson1401.html. Accessed 30 May 2015.

Askol'dov, Aleksandr (1957), 'Vosem' snov', *Teatr*, 8, pp. 61–66.

––––– (1965), *Komissar /kinopovest' 1920 goda. Literaturnyi stsenarii po motivam rasskaza V. Grossmana*, RGALI 2468/6/220.

––––– (1990), 'U menia sushchestvovala svoia model' nravstvennoi revoliutsii', *Ekran i stsena*, 25 January, pp. 10–11.

––––– (1991), 'Eshche k istorii fil'ma "Komissar"', *Izvestiia*, 24 April.

––––– (1996), 'Neudachnik', *Iskusstvo kino*, 8, pp. 117–20.

––––– (2004a), 'I tut ia pervyi raz zaviazal shnurki…', *Novyi bereg*, 4, http://magazines.russ.ru/bereg/2004/4/aa16.html. Accessed 15 June 2015.

––––– (2004b), *Komissar*, Moscow: RUSCICO DVD.

––––– (2013), *La Commissaire*, Paris: Editions Montparnasse.

Askoldow, Alexander (1991), 'Über Michail Bulgakow', in B. Langerbein (ed.), *Über Literaturen in der 'Sowjet Union'*, Berlin: Heinrich Böll Stiftung, pp. 105–16.

––––– (1998), *Heimkehr nach Jerusalem*, Berlin: Volk & Welt.

Babel, Isaac (2002), *The Complete Works* (trans. P. Constantine), New York: Norton.

Babel', Isaak (1966), *Izbrannoe*, Moscow: Khudozhestvennaia literatura.

Balaian, Valerii (2006), *Sud'ba Komissara/The Fate of The Commissar*, Mosfil'm Studio, Moscow.

Barratt, Andrew (2001), 'In the name of the father: The Eisenstein connection in films by Tarkovsky and Askoldov', in A. Lavalley and B. Scherr (eds), *Eisenstein at 100: A Reconsideration*, New Brunswick, NJ: Rutgers University Press, pp. 148–60.

Bartov, Omer (2005), *The 'Jew' in Cinema: From the Golem to Don't Touch My Holocaust*, Bloomington, IN: Indiana University Press.

Ben Natan, F. (2012), 'Sud'ba "Komissara"', *Kaskad*, 21 June, http://kackad.com/kackad/sudba-komissara. Accessed 15 June 2015.

Berghahn, Daniela (2006), 'Do the right thing? Female allegories of nation in Aleksandr Askoldov's *Komissar* (USSR, 1967/87) and Konrad Wolf's *Der Geteilte Himmel* (GDR, 1964)', *Historical Journal of Film, Radio, and Television*, 26: 4, pp. 561–77.

Bethea, David (1989), *The Shape of Apocalypse in Modern Russian Fiction*, Princeton, NJ: Princeton University Press.

Bossart, Alla (2007), 'Kodeks Askol'dova', *Novaia gazeta*, 21 June, http://novayagazeta.ru/arts/35190.html. Accessed 20 June 2015.

Bulgakov, Mikhail (2011), *Zapiski iunogo vracha. Morfii. Zapiski na manzhetakh. Zapiski pokoinika*, Moscow: Azbuka-Attikus.

----- (2008), *White Guard* (trans. M. Schwartz), New Haven, CT: Yale University Press.

Chernenko, Miron (2006), *Krasnaia zvezda, zheltaia zvezda: kinematograficheskaia istoriia evreistva v Rossii*, Moscow: Tekst.

De Baecque, Antoine (2012), *Camera Historica: The Century in Cinema*, New York: Columbia University Press.

Deppermann, Maria (1997), 'The genealogy of the woman commissar in Soviet culture: Askol'dov's film *The Commissar* – A farewell to arms of socialist realism', in W. Gortschacher (ed.), *Modern War on Stage and Screen*, Lewiston, ME: Edwin Mellen Press, pp. 559–83.

Demchyk, S. (1966), 'Uvaga! Ide z'iomka', *Prapor zhovtnia*, 24 September, p. 4.

Denby, David (1988), 'Movies', *The New Yorker*, 8 August, p. 45.

Dolin, Anton (2011), *German: Interv'iu, esse, stsenarii*, Moscow: Novoe literaturnoe obozrenie.

Ermakova, E. (1990), '20 let spustia…', *Tekhnika kino i televideniia*, 8, pp. 9–13.

Evtushenko, Evgenii (1988), 'Epokha vozvrashchaemykh poter', *Sovetskaia kul'tura*, 13 February, p. 5.

Fomin, Valerii (1990), 'Etot fil'm nikogda ne uvidit sveta', *Ekran i stsena*, 25 January, pp. 10–11.

Genette, Gérard (1997), *Palimpsests: Literature in the Second Degree*, Lincoln, NE and London: University of Nebraska Press.

Gershenson, Olga (2013), *The Phantom Holocaust: Soviet Cinema and Jewish Catastrophe*, New Brunswick, NJ: Rutgers University Press.

Ginzburg, Valerii (1991), 'Ne soglasen s Askol'dovym', *Izvestiia*, 8 July.

Gorin, B. (2014), 'Audientsiia moskovskogo ravvina Ieudy-Leiba Levina u Rebe v 1958 godu', *Lechaim*, 1, http://www.lechaim.ru/ARHIV/261/poslaniya-lubavichskogo-rebe.htm. Accessed 5 July 2015.

Grinberg, Marat (2013), '*I am to Be Read not from Left to Right, but in Jewish: from Right to Left*': The Poetics of Boris Slutsky, Brighton: Academic Studies Press.

Grossman, Vasily (2010), *The Road: Stories, Journalism, and Essays*, New York: New York Review of Books.

Grossman, Vasilii and Erenburg, Il'ia (eds) (2015), *Chernaia kniga*, Moscow: AST.

Hicks, Jeremy (2012), *First Films of the Holocaust: Soviet Cinema and the Genocide of the Jews, 1938–1946*, Pittsburgh, PA: University of Pittsburgh Press.

Hoberman, J. (1988a), 'Ask Askoldov', *Village Voice*, 8 April.

----- (1988b), 'Red Psalm', *Village Voice*, 21 June, pp. 63–70.

Iampolski, Mikhail (1998), *The Memory of Tiresias: Intertextuality and Film*, Berkeley, CA: University of California Press.

Jazairy, Hadi E. (2009), 'Cinematic landscapes in Antonioni's *L'avventura*', *Journal of Cultural Geography*, 26: 3, pp. 349–67.

Kauffmann, Stanley (1988), 'Twenty years later', *New Republic*, 4 July, pp. 24–25.

Khazan, Vladimir (2001), *Osobennyi evreisko-russkii vozdukh: k problematike i poetike russko-evreiskogo dialoga v XX veke*, Moscow: Mosty kul'tury.

Khazdan, E. (2012), 'Nasledie Nekhamy Lifshitsaite', *Narod knigi v mire knig*, 10, http://narodknigi.ru/journals/100/nasledie_nekhamy_lifshitsayte/. Accessed 25 July 2015.

Kilb, Andreas (1988), 'Die Nacht von Berditschew', *Die Zeit*, 28 October, http://www.zeit.de/1988/44/die-nacht-von-berditschew?page=all. Accessed 15 August 2015.

Kim, Svetlana (1967), 'Komissar', *Sovetskii ekran*, 8, pp. 12–13.

Kondakov, Igor' (2001), 'Nashe sovetskoe "vse", (Russkaia literatura XX veka kak edinyi tekst)', *Voprosy literatury*, 4, http://magazines.russ.ru/voplit/2001/4/kondak.html. Accessed 20 July 2015.

Kuprin, Aleksandr (1971), *Sobranie sochinenii v deviati tomakh*, vol. 3, Moscow: Khudozhestvennaia literatura.

Lastovka, T. (2012), *Tuneiadstvo v SSSR 1961–1991: iuridicheskaia teoriia, sotsial'naia praktika i kul'turnaia representatsiia*, Zurich: Zurich University, http://www1.unisg.ch/www/edis.nsf/SysLkpByIdentifier/4058/$FILE/dis4058.pdf. Accessed 5 July 2015.

Lipkin, Semen (1997), *Kvadriga*, Moscow: Agraf.

Mandel'shtam, Osip (1993), *Sobranie sochinenii*, vol. 2, Moscow: Art-Biznes-Tsentr.

Margolit, Evgenii (2012), *Zhivye i mertvye: zametki k istorii sovetskogo kino 1920–1960-kh godov*, St. Petersburg: Masterskaia Seans.

Markulan, Ianina (1967), *Kino Pol'shi*, Moscow: Iskusstvo.

Martin, Adrian (2014), *Mise en Scene and Film Style: From Classical Hollywood to New Media Art*, Basingstoke: Palgrave Macmillan.

Menashe, Louis (2010), *Moscow Believes in Tears: Russians and Their Movies*, Washington, DC: New Academia Publishing.

Milne, Leslie (1990), *Mikhail Bulgakov: A Critical Biography*, Cambridge: Cambridge University Press.

Monastireva-Ansdell, Elena (2006), 'Redressing *The Commissar*: Thaw cinema revises Soviet structuring myths', *The Russian Review*, 65, pp. 230–49.

Reynaud, Bérénice (1988), 'Le long chemin de "La Commissaire"', *Cahiers du cinema*, 9, pp. 22–25.

Rivette, Jacque (1961), 'On abjection', http://www.dvdbeaver.com/rivette/ok/abjection.html. Accessed 15 July 2015.

Ro'i, Yakov (2008), 'The Soviet Jewish reaction to the Six Day War', in Yakov Ro'i and B. Morozov (eds), *The Soviet Union and the June 1967 Six Day War*, Washington, DC: Stanford University Press, pp. 251–67.

Roberts, Graham (2005), 'The sound of silence: From Grossman's Berdichev to Askol'dov's *Commissar*', in Anat Vernitski and Stephen Hutchings (eds), *Russian and Soviet Film Adaptations of Literature, 1900–2001: Screening the Word*, London: Routledge, pp. 89–99.

Rokhlenko, B. (2007), 'Aleksandr Askol'dov? Eto – "Komissar"', part 5, *Shkola zhizni*, 12, http://shkolazhizni.ru/archive/0/n-11425/. Accessed 1 August 2015.

Rukeyser, Muriel (2004), *Selected Poems*, New York: The Library of America.

Sartre, Jean Paul (2008), 'Letter on the critique of Ivan's Childhood', in Nathan Dunne (ed.), *Tarkovsky*, London: Black Dog Publishing, pp. 34–45.

Sicher, Ephraim (2012), *Babel' in Context: A Study in Cultural Identity*, Boston, MA: Academic Studies Press.

Sikora, Eduard (2010), *Litsa Kamentsa-Podol'skogo*, Kharkov: Mis'kdruk.

Sinel'nikova, G. (1988), 'Komissar', *Sovetskaia kul'tura*, 13 August, p. 3.

Slezkine, Yuri (2006), *The Jewish Century*, Princeton, NJ: Princeton University Press.

Slutskii, Boris (1991), *Sobranie sochinenii*, vol. 2, Moscow: Khudozhestvennaia literatura.

Snyder, Timothy (2012), *Bloodlands: Europe between Hitler and Stalin*, New York: Basic Books.

Stishova, Elena (1989), 'Strasti po "Komissaru"', *Iskusstvo kino*, 1, pp. 110–21.

––––– (1993), 'The mythologization of Soviet woman: *The Commissar* and other cases', in Lynn Attwood (ed.), *Red Women on the Silver Screen: Soviet Women and Cinema from the Beginning to the End of the Communist Era*, London: HarperCollins, pp. 175–85.

Stone, Judy (1997), 'Interview with Alexsandr Askoldov', in *Eye on the World: Conversations with International Filmmakers*, Los Angeles: Silman-James Press, pp. 513–16.

Troianovskii, V. and Fomin, Valerii (eds) (1998), *Kinematograf ottepeli: dokumenty i svidetel'stva*, Moscow: Materik.

Tsivian, Yuri (2008), *Ivan the Terrible*, London: British Film Institute.

Usok, I. (ed.) (1965), *Sovetskie poety, pavshie na Velikoi Otechestvennoi Voine*, Leningrad: Bol'shaia biblioteka poeta.

Vail', Petr and Genis, Aleksandr (1988), *60-e: mir sovetskogo cheloveka*, Ann Arbor, MI: Ardis.

Venediktov, Aleksei (2001), 'Istoriia fil'ma A. Askol'dova "Komissar". Predstoiashchee vruchenie premii "Oskar"', *Radio Ekho Moskvy*, 24 March, http://echo.msk.ru/programs/beseda/14028. Accessed 1 July 2015.

Viniukov, O. (1988), *Kamenets-Podolsky*, Kiev: Mystetstvo.

Voronel', Aleksandr (2007), 'Shestidnevnaia voina – prichina ili predlog?', *Lekhaim*, 11, www.lechaim.ru/ARHIV/187/voronel.htm. Accessed 20 June 2015.

Wolf, William and Williamson, Anne (1988), 'Askoldov!: The man who made "Commissar"', *Film Comment*, 24: 3, pp. 68–72.

Wyllie, Barbara (2003), *Nabokov at the Movies*, Jefferson, MO: McFarland & Company.

Zholtovskii, Pavel (1966), 'Pamiatniki evreiskogo iskusstva', *Dekorativnoe iskusstvo SSSR*, 9, pp. 28–32.

<u>Notes</u>

1. Askol'dov stated regarding his father: 'This is a special topic which I didn't touch for a variety of reasons. He is the little key to my problems (personal communication 24 April 2015)'.

2. Unlike in all other sources, Magazanik is spelled here with a double N.

3. The literary analogue would be the publication of Anatolii Rybakov's novel *Tiazhelyi pesok/Heavy Sand* (1978), which told the story of a Russian-Jewish family during the Holocaust, using the tropes and conventions of heroic Soviet war fiction.

4. For a detailed discussion of 'parasitism' in the Soviet Union, including Askol'dov's case, see Lastovka (2012).

5. Askol'dov's documentaries about the main Soviet automobile factory are *Tovarishch KamAZ/Comrade KamAZ* (1972) and *Sud'ba moia KamAZ/My Fate KamAZ* (1975). Both are available for viewing at https://www.youtube.com/watch?v=-QwZnW6vl9o.

6. Such banned psychological dramas as Kira Muratova's *Korotkie vstrechi/Short Encounters* (1967; released 1986) and *Dolgie provody/ Long Farewells* (1971; released 1986) were distinguished by their meaningful silences and absences. Other films whose release was postponed or banned used historical or comedy genres to hide their anti-regime thinking. Andrei Tarkovskii's *Andrei Rublev* (1966; released 1971), a historical drama, and Gennadii Poloka's *Interventsiia/Intervention* (1967; released 1986), a satirical comedy, fall into this category.

7. A reflection of Askol'dov's ambivalence about the story is his statement that Grossman depicts Magazanik as a 'sub-human' [*nedochelovek*] (Askol'dov 2004).

8. A great example of this model of Civil War representation is the Lithuanian film *Nikto ne khotel umirat'/Niekas nenorėjo mirti/Nobody Wanted to Die* (1966), beloved by Askol'dov. The film's director, Vytautas Žalakevičius, was Askol'dov's close friend. Though the film describes the events in Lithuania after World War II, it serves as an analogy to the Civil War era.

9. In answer to my question about whether and how Babel' impacted on his thinking, Askol'dov said: 'I cannot say. But probably Babel' was on my mind (personal communication April 2015)'.

10. Stefan Batory, also known as Stephen Báthory, was the Polish king from 1576–586.

11. As an example of how the other films which aimed at incorporating religious imagery into the *mise-en-scène* had to decentralize it, see *Gori, gori moia zvezda/Shine, Shine My Star* (Mitta, 1970). The film is also a notable example of the implicit presentation of Jewishness. It takes place in a *shtetl* (or *mestechko*) but does not feature a single explicitly Jewish character.

12. The first screen version of the story is Iakov Protazanov's adaptation of 1927.

13. Interestingly, the Kamenets locals referred to the houses of the Jewish poor as bedbug residencies [*klopovniki*].

14. The interview with Bykov can be found in the supplementary materials of the *Komissar* DVD (Askol'dov 2004b).

15. For information about this fascinating event, see Gorin (2014).

16. A great example of these aspects of Soviet Jewish mentality is the largely autobiographical protagonist of Grossman's *Life and Fate*, the physicist Viktor Shtrum.

17. The film was also accused of being anti-Russian due to the unappealing nature of Vavilova's character.

18. The *mezuzah* [doorpost in Hebrew] is a piece of parchment in a decorative case, inscribed with verses from Deuteronomy and affixed to the doorframe of Jewish homes. Ginzburg mistakenly states that the *mezuzah* is similar to the Russian horseshoe, kept in the house for good luck (Ermakova 1990: 11).

19. While in English Efim seems to allude to Babel's cycle of stories, the Russian title of the cycle is 'Konarmiia'/'Horse Army' as opposed to 'Krasnaia kavaleriia'/'Red Cavalry'.

20. See in particular Chapter 9 of the Gospel of John, where seeing equals sin and blindness equals redemption.

21. An iconic figure of the Thaw, the poet Evgenii Evtushenko commented in his early short piece on *The Commissar* that the film is 'close to Platonov' (Evtushenko 1988: 5).

22. I am grateful to G. B. Kivil'sha, head of the National Historical Architectural Sanctuary 'Kamenets', for providing information about the synagogue and history of the Jews in Kamenets-Podol'skii.

23. It is notable that the only article published in the Soviet Union on Ukrainian synagogues and traditional Jewish art came out in the autumn of 1966, just as Askol'dov began shooting *The Commissar* (see Zholtovskii 1966: 28–32).

24. Peter Brook's renowned screen adaptation of the novel, which Askol'dov might have seen, had been released, however, in 1963.

25. Askol'dov is very fond of this phrase. He uses it as the epigraph to his novel, *Return to Jerusalem*, available only in German translation (Askoldow 1998).

26. See, for instance, Nikolai Gumilev's poem 'Zabludivshiisia tramvai'/'The Lost Tram' (1919).

27. As an interesting parallel, the speaker of Boris Slutskii's poem, 'Now I often dream of Auschwitz…'/'Teper' Osventsim chasto snitsia mne…' has a dream of walking in the camp on his way to the gas chamber and observing the surroundings.

28. Unlike the grandmother, the women's kerchiefs cover their ears.

29. This includes Evgenii Evtushenko's poem 'Babii Iar', Anatolii Kuznetsov's documentary novel *Babii Iar* (1966), and Boris Slutskii's poems, among others.

30. In its emphasis on the link between Jewishness and death, *The Commissar* recalls Andrzej Wajda's *Samson* (1961) about a flight from the ghetto.

31. For an extended discussion of *The Unvanquished* and the Holocaust in Soviet cinema, see Gershenson (2013) and Hicks (2012).

32. On the Holocaust in Kamenets-Podol'skii, see Anon (2013). For an eyewitness account of the actual procession to the shooting site in Kamenets, see Grossman and Erenburg (2015: 689–96).

33. The beating of the horse could also be an allusion to Fiodor Dostoevskii's *Crime and Punishment*, where the protagonist Raskol'nikov has a nightmare about the killing of a horse.

34. The video recording of Askol'dov's speech is included in the documentary *Sud'ba Komissara/The Fate of* The Commissar (Balaian, 2006).

35. Askol'dov (2004) stated: 'This is a film about Russia – not about Jews – the Jews are merely the film's construction material'.